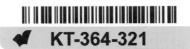

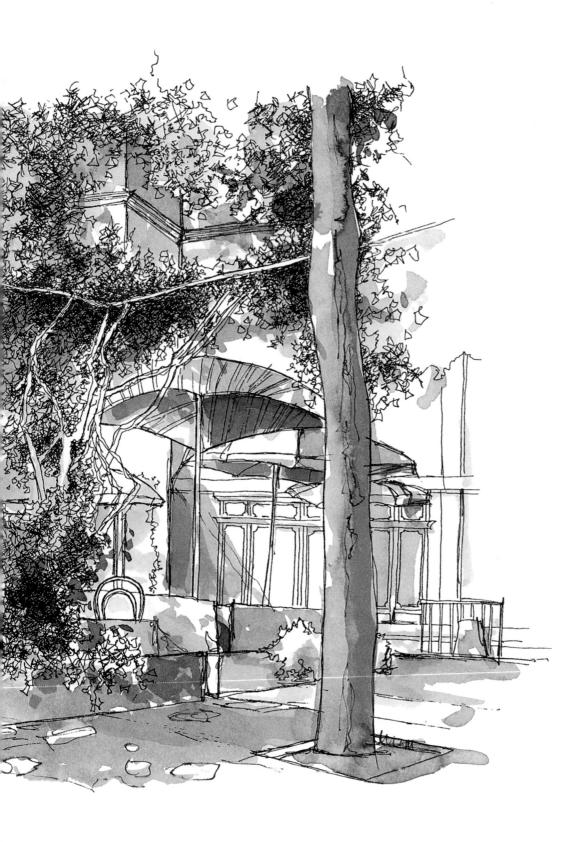

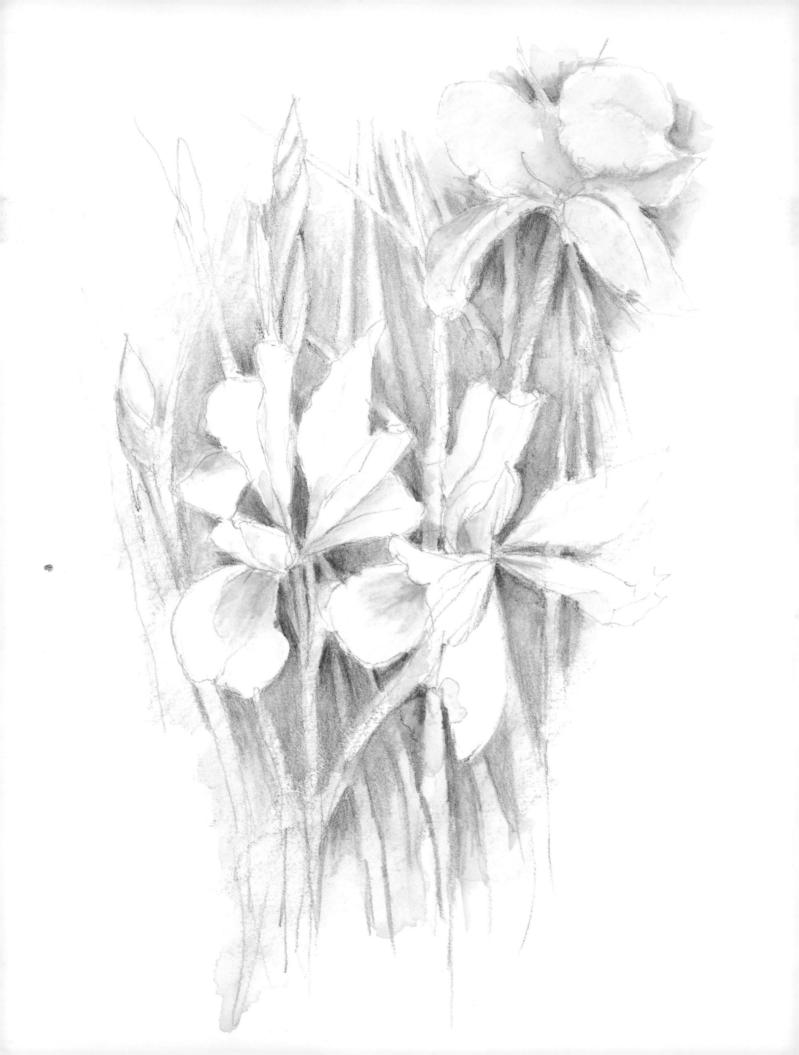

RICHARD TAYLOR

Learn to Draw in a Weekend

A DAVID & CHARLES BOOK Copyright © David & Charles Limited 2006

David & Charles is an F+W Publications Inc. company 4700 East Galbraith Road Cincinnati, OH 45236

First published in the UK in 2006 Reprinted 2007

Text and illustrations copyright © Richard Taylor 2006

Richard Taylor has asserted his right to be identified as author of this work in accordance with the Copyright, Designs and Patents Act, 1988.

All rights reserved. No part of this publication may be reproduced, stored in a retrieval system, or transmitted, in any form or by any means, electronic or mechanical, by photocopying, recording or otherwise, without prior permission in writing from the publisher.

A catalogue record for this book is available from the British Library.

ISBN-13: 978-0-7153-2425-7 hardback ISBN-10: 0-7153-2425-X hardback

ISBN-13: 978-0-7153-2424-0 paperback ISBN-10: 0-7153-2424-1 paperback

Printed in China by SNP Leefung for David & Charles
Brunel House Newton Abbot Devon

Commissioning Editor Mic Cady Assistant Editor Louise Clark Project Editor Ian Kearey Art Editor Sarah Underhill Designer Sarah Clark Production Controller Kelly Smith

Visit our website at www.davidandcharles.co.uk

David & Charles books are available from all good bookshops; alternatively you can contact our Orderline on 0870 9908222 or write to us at FREEPOST EX2 110, D&C Direct, Newton Abbot, TQ12 4ZZ (no stamp required UK only); US customers call 800-289-0963 and Canadian customers call 800-840-5220.

Contents

Introduction	4	Project : Linen suit	64
		Organic forms	66
Materials	6	Texture	68
Pencils	8	Colour	70
Coloured pencils	10	Compilation	72
Watersoluble pencils	12	Project: Shopping bag	74
Pen and ink	14	Windows	76
Watercolour	16	Doorways	78
Basic techniques	18	Project: Open French windows	80
Line	20	Outdoor drawing: Sunday	82
Tone	22	Garden pots	84
Light and shade	24	Flowers	86
Positive and negative shapes	26	Gardening tools	88
Measuring	28	Trees	90
Format	30	Project: Spring scene	92
Tabletop perspective	32	Farmyards	94
	71	Harbours	96
Indoor drawing: Saturday	34	Cafés and bars	98
Round objects	36	Shop fronts	100
Shading on round objects	38	Project: Market	102
Shadows on round objects	40	Garden sheds	104
Transparency and reflections	42	Huts and cabins	106
Project : Distortion through glass	44	Cottages	108
Rectangular objects	46	Project: Wooden barn	110
Shading on rectangular objects	48	Skies	112
Shadows on rectangular objects	50	Creating depth	114
Adding detail	52	Panoramic seascape	116
Project: Open briefcase	54	Project: Country lane	118
Still life	56		
Shading on still lifes	58	Final thoughts	120
Patterns	60	Index	121
Foregrounds	62		

Introduction

Drawing has, for centuries, been the lifeblood of artists: Leonardo da Vinci drew, Pablo Picasso drew, and so did numerous artists whose names are not so readily acknowledged by history. But these people did not draw just to enable them to produce paintings; they drew for the sake of drawing.

Drawing is the first art form that most of us encounter. At a very early age we are given crayons, and in our first days at school we are encouraged to draw pictures that inform teachers about our life outside school. All of us have some drawing ability somewhere inside, and the purpose of this book is to help you to bring that ability out and to develop it into something you will be proud of.

Drawing in a weekend may seem like rather a tall order, but if you use your weekends in a structured way – practising for ten minutes before you set the breakfast table, for example, then ten minutes before you begin to work in the garden, always drawing objects that are part of your daily activities – then you will see progress over a series of weekends. I shall be with you all the way through the pages of this book and, hopefully, our weekends will be highly profitable in terms of drawings created.

How to use this book

This book is structured to take you from drawing the most basic of shapes at your kitchen table through to sketching on the quayside at a harbour, making drawings of the boats, the sea and sky – and the many stages in between. Work through the book from start to finish, taking as long as you like to practise the different skills explored in the following pages. Every now and again you will come across 'Try it yourself' exercises; these are timed to encourage you to capture the essence of certain shapes or objects and not to spend too long fiddling with lines or tones. The first few minutes of any drawing are decisive, and the quicker and more confident you are in your approach, the greater the likelihood of success.

The step-by-step drawing sequences are designed to show you how drawings can progress from simple shapes to complex images. You may wish either to copy the drawings, or to set up similar subjects yourself and draw them from life. Translating a two-dimensional image onto a two-dimensional surface requires a certain level of skill –

but the skill you should really be aiming to develop is translating three-dimensional objects onto a twodimensional sheet of paper.

As you move through the book, you will note that hardly any of the drawings have been made within a rectangle or are bound by hard-edged lines. The reason for this is simple – I do not like to feel restricted in my drawing from the outset by knowing that I cannot extend the marks made outside four arbitrarily set outlines.

This leads me on to my final point: when is a drawing finished or complete? If you work within a series of visual boundaries, you will probably judge that your drawing is finished when you have taken it out to the hard edges and filled in the space in between. But this attitude is unnecessarily restrictive. Your drawing may well be finished before you even reach the outline border, but you may feel as if you have to keep working on it. I like to start with my main object and work around it, making my own decision about when I stop – and I strongly recommend that you do the same!

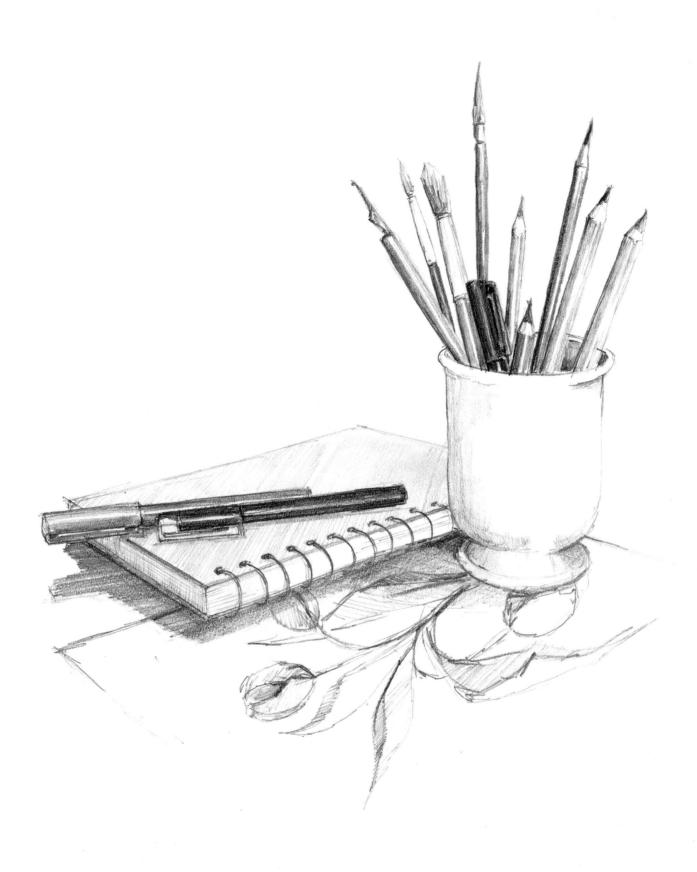

Materials

It is a fact that you can draw with almost anything – a burnt stick, a finger dipped in coffee, even a foot in sand. Most of us, however, require something a little more permanent, and usually opt for more conventional pencils and pens. But you do not need to be elitist about this – you can draw with a ballpoint pen or a child's handwriting pen. The office stationery cupboard may not be so appealing as the art store, but they both hold enough equipment to allow your drawing skills to develop.

The starting point has to be the surface – what exactly do you draw onto? Start with a ringbound cartridge paper sketchpad – around 100 sheets should suffice; these pads allow you to fold each sheet of paper back on itself without creasing or tearing the paper, while cartridge paper is an excellent multi-purpose paper that allows you to draw with pen, pencil and watercolour paints. Ringbound pads also allow you to keep all your drawings together, enabling you to look back at your progress at any point.

As with anything to do with art, the materials and processes are difficult to categorize, but I have included three distinct types of drawing materials: dry (pencils), wet (ink and watercolour paints) and the particularly useful dry and wet watersoluble pencils.

Starting with dry materials, you can draw with any type of pencil, but a set of B grade (soft) pencils – 2B, 4B, 6B, 8B – should cover any subject. The standard issue HB pencil can always be used in an emergency, but is restrictive because of the 'neutral' quality of the lead. Coloured pencils come in a wide variety of types and colours, but they can all be blended and used for an amazing selection of subjects. (Charcoal, pastels and all manner of 'crayons' fall into the dry category, but these materials need careful handling and are best used once you reach the next phase of drawing.)

Wet materials include ink pens, Indian ink and watercolour paints – yes, I do include paints as materials with which you can draw: if drawing is about recording shapes of objects using line and tone to create the illusion of three-dimensional space and form on a flat surface, paints can be used perfectly legitimately within this definition. Watercolour paints allow you to tint a drawing quickly and effectively, as their translucent qualities allow any line drawing to show through, keeping the essence of the drawing technique intact. The same applies to inks – they can become an integral part of the drawing process as long as they remain subservient to the underlying pen or pencil line drawing.

My other favourites are watersoluble pencils. These come in two types: watersoluble graphite pencils, which can be used as normal graphite pencils or washed across with a wet paintbrush to activate the grey pigment, creating soft, watery tones of grey. Watersoluble coloured pencils are used in exactly the same way, only you can blend two or more colours together and then wash over these with water to completely change the nature of the original pencil marks. Alternatively, you can produce a monochrome colour drawing – sepia pencils can be very effective for this. Finally, a few peripheral items come in handy. I use a kneaded eraser, which is soft and pliable, and does not damage the surface of the paper. A good pencil sharpener is vital, and you can spray any pencil drawing with a fixative spray to prevent your work from smudging.

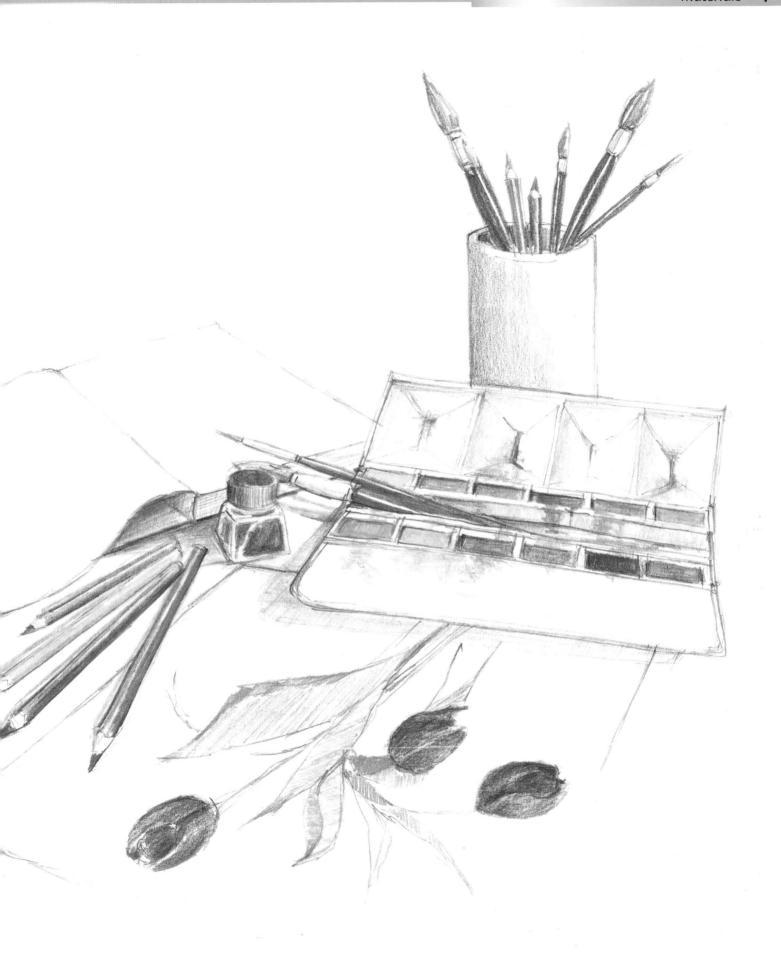

Pencils

The pencil is probably the implement that most people immediately associate with the term 'drawing' – and not unreasonably, as it is a clean, easily accessible implement that can be found easily anywhere.

A pencil is basically a compressed stick of graphite (the 'lead') encased within a thin wooden shell. It is the quality and grade of the graphite that makes different types of pencils more suited to certain subjects.

Pencils are divided into two categories, H (hard) and B (soft), which are then further divided by number -9B being extremely soft and 2B being fairly soft. Artists rarely have much use for H-grade pencils.

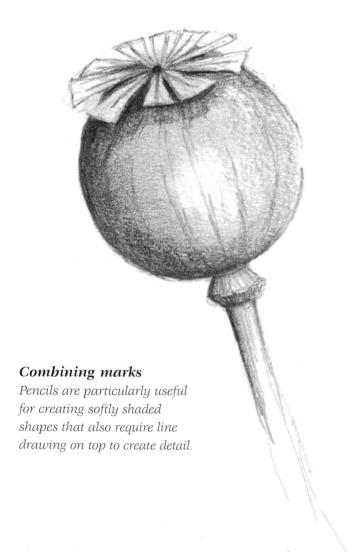

Pencil techniques

Despite their simplicity, pencils are highly versatile and can be used to make a variety of different marks.

Line drawing using the tip of the pencil lead.

Shading using the edge of the pencil lead.

Experiment with different pressures – press hard for darker lines and more lightly for softer marks.

Crosshatching is a technique that involves using the same pressure to maintain even lines drawn on top of each other.

Grades

These marks illustrate the range of tones achievable by using different grades of B pencils.

B

2B

TRY IT YOURSELF

Draw the outline of an egg using a B pencil. Then, using the edge of a 2B pencil, shade the egg, easing off the pressure towards the centre, where it will appear lighter.

Allow two minutes.

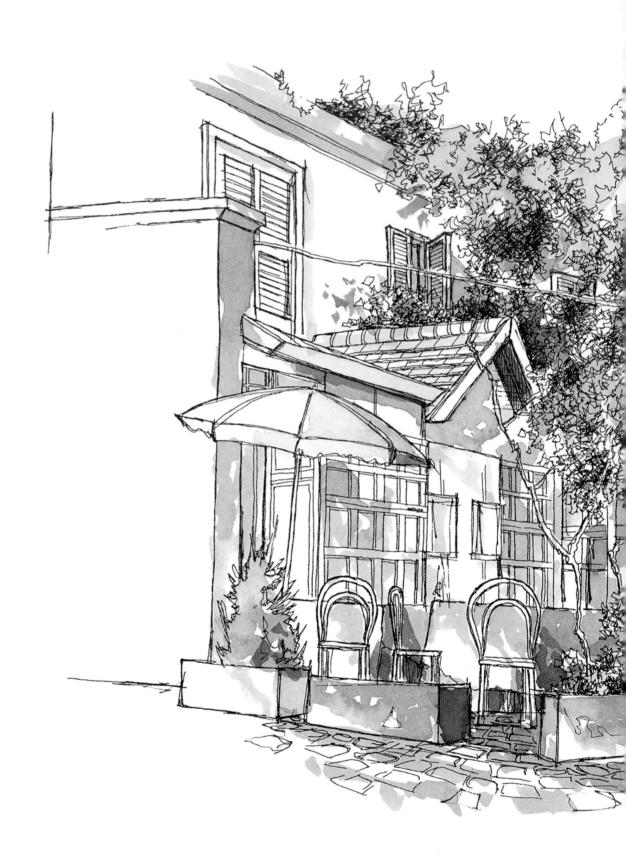

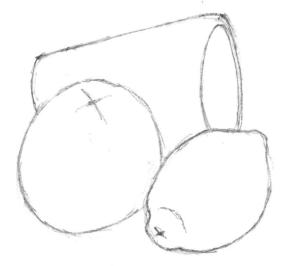

1 To make this line drawing of the basic shapes of a group of objects, use the sharpened tip of a B pencil.

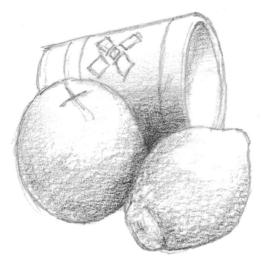

2 Next, add the main tones by drawing onto the shapes using the edge of a 4B pencil, working in a circular motion.

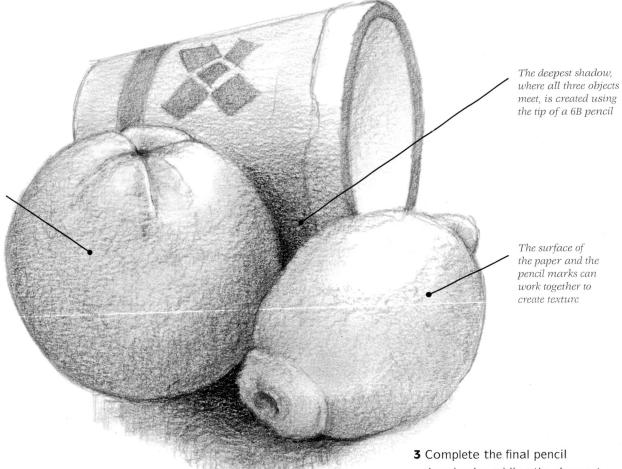

The 'middle' tones form the basis for the orange and are drawn with the edge of the pencil to create a softer effect

> the paper and the pencil marks can work together to create texture

drawing by adding the deepest and darkest shadows with a very soft 6B pencil.

Coloured pencils

Coloured pencils have the great advantages of being highly portable and inexpensive. They come in a wide variety of colours and can really make a drawing come alive. They can also be blended easily, allowing you to create an amazing range of tones, and usually have good covering power.

You may remember using these versatile pencils in school only for 'colouring in' to give bulk to line drawings – but they are capable of producing drawings in their own right and don't need to be restricted to producing flat blocks of colour. Their potential is, in fact, unlimited: simply apply the same methods of working as you would with graphite pencils at first – drawing with the tip and edge and working one tone across another - and practise blending different tones to see how many you can achieve.

Coloured pencil techniques

With only a few pencils you can achieve a very wide range of tones by blending, varying the pressure you apply and using both the tip and edge of the pencil lead.

Use the edge of the pencil lead to create broad areas of colour.

A wealth of dark tones can be created by 'overdrawing' - drawing one tone on top of another.

Experiment with two completely different colours to see what type of tones you can achieve.

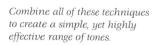

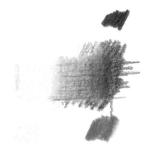

Colours

Apart from the brown stem, this apple was drawn using only four colours, yet it would be difficult to count the number of new colours and different tones created by blending the coloured pencils.

Yellow

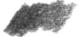

Red

Green

Violet

TRY IT YOURSELF

Take a single-coloured fruit, such as a melon, and draw it with coloured pencils. Use only two pencils to create three different tones dark, middle and light. Allow five minutes.

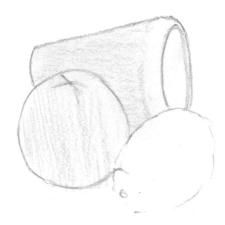

1 The first stage is to block in the main colours – don't worry about creating tones at this stage.

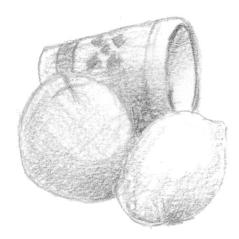

2 Next, use violet to draw on top of the colours, recording the shapes of the shadows.

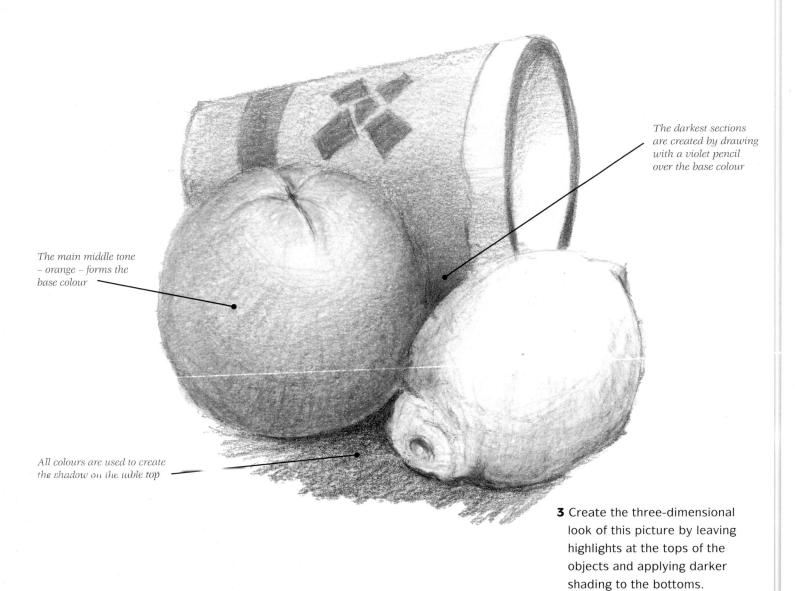

Watersoluble pencils

Watersoluble pencils are remarkably versatile, as they can not only be used as normal pencils for either line drawing or shading, but they can also be washed across with a wet, soft brush to create a watercolour effect.

Watersoluble coloured pencils contain solid sticks of coloured pigment that can be dissolved with water, making them valuable, multipurpose drawing tools.

Watersoluble graphite pencils work to the same principle, except that when washed across they produce tones of grey instead of colour. Both types of pencils have great potential and are certainly worth experimenting with.

Watersoluble coloured pencil

Only use a soft brush to wash across a watersoluble pencil drawing and wet the pencil marks, rather than scrubbing at them with a harder brush.

A simple wash across one colour creates a watery look.

Pencils can be blended to create tones before being washed over.

TRY IT YOURSELF

Take an orange and two watersoluble coloured pencils - orange and purple. Draw the outline of the fruit with the orange and block in the colour using the edge. Lightly shade the base with purple and wash over the colour, working from the light top to the darker base. Allow four minutes.

Making greys

The drawing techniques for graphite and colour watersoluble pencils are the same, but you will need to practise more with graphite pencils to get used to the subtle tones of grey.

Washing across a dry graphite drawing produces a similar tone.

Once a wash has dried, draw over it with the tip of a pencil for line effects.

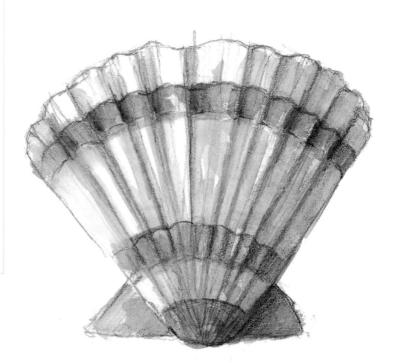

Watersoluble graphite pencil

This seashell contains a wealth of soft tones with only a little linear detail and is thus ideal for drawing with a watersoluble graphite pencil.

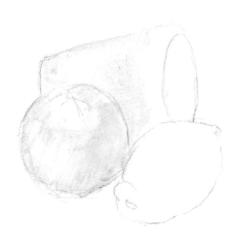

1 First block in the shapes with appropriate colours; don't worry too much about tone at this stage.

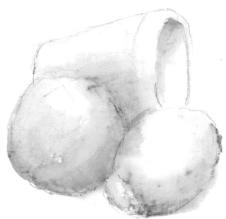

2 Next, choose a warm colour such as purple or violet to draw onto the previous stage to create the shadows and darker tones. Then wash across the shapes with a wet brush.

Orange

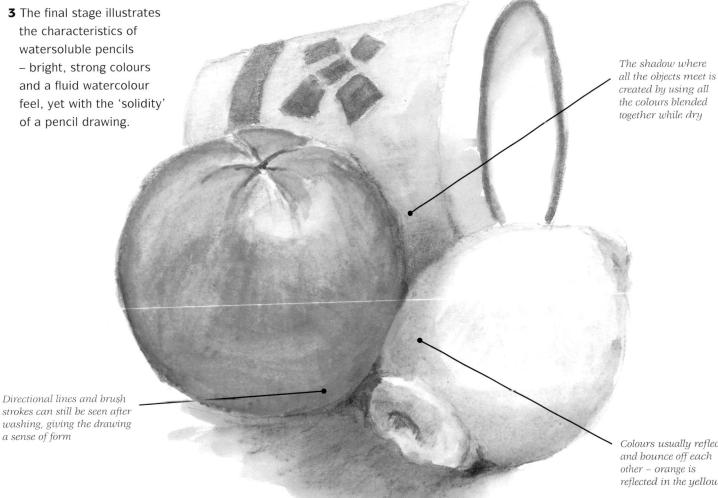

Colours usually reflect and bounce off each other – orange is reflected in the yellow

Pen and ink

You can draw with any type of pen you choose – a ballpoint or fountain pen can be used effectively – but there are two types that are particularly well suited to drawing for the following reasons.

Most 'fineline' or permanent ink pens are designed for artists, and produce sharp, fine lines that do not run or bleed, no matter what you do to them. Using these pens you can produce fine line drawings that require no more treatment; alternatively you can dilute some Indian ink and add tone to a line drawing by washing this onto your picture using a soft brush.

The other type is the fibre-tip pen (often used for writing). The ink in these pens often is not permanent, which gives you the opportunity to wash across a line drawing with plain water to create subtle bleeds and tones.

Pen and ink techniques

Because ink will stain your paper on contact, you will need to think well in advance about exactly where you want it and how much you plan to use; this has the advantages of forcing you to observe well and ensuring that you don't fiddle with your drawing.

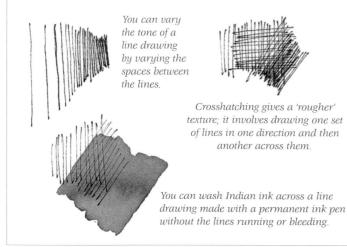

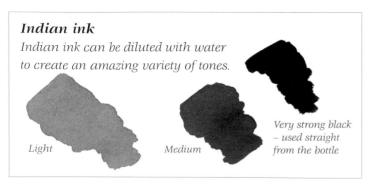

Fibre-tip pens

Fibre-tip pens can be used for line drawing and washed across to create tonal bleeds, as well for creating line drawings in the same style as permanent ink pens.

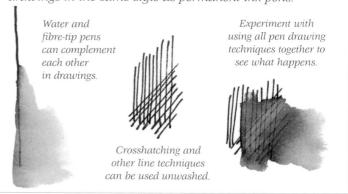

Line and tone

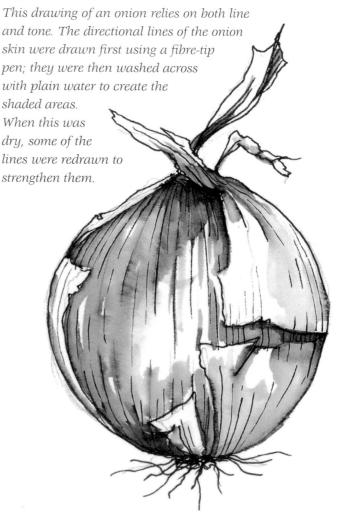

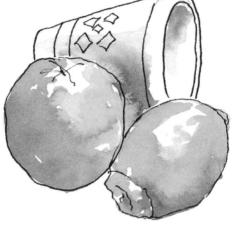

1 Record the curved shapes of the group of objects using waterproof ink.

tone for the base shadows

2 Using very diluted ink, select the darkest areas of the group and wash this on, starting at the bottom and pulling up towards the light areas.

TRY IT YOURSELF

Draw a pair of bananas using a fibre-tip pen, recording all the shapes in line. Then use a wet, soft brush to create the shading, starting at the bottom and working up towards the light. Allow five minutes.

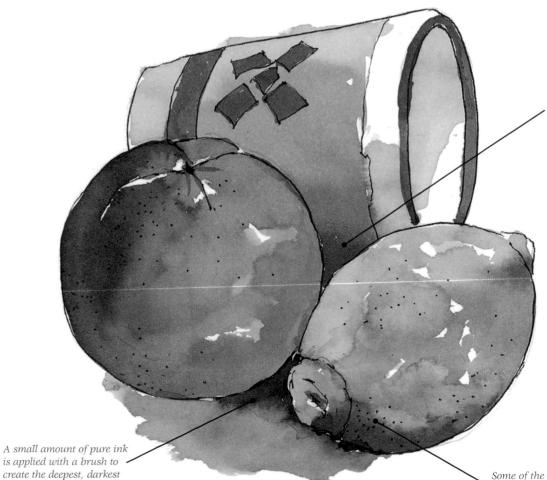

The point at which all three objects meet is darkened with a medium wash, created by adding more ink to the previously diluted application

drawing is not so much the variety of tones achieved by subtle dilution of the ink, but more the highlights that were left alone. You always need highlights in any drawing, and if they can reflect the texture of your objects, so much the better.

Some of the texture of the lemon is created by dotting or stippling with the tip of the pen

Watercolour

Although watercolour is a medium more usually associated with painting, it can easily be used in a way that allows it to fit into the category of drawing. The key difference is that for drawing purposes, watercolour is used primarily to complement linear illustrations, rather than using its pure colour to create an image.

To draw with watercolour paints you will need a couple of soft watercolour brushes (usually sable or squirrel hair) and a suitable watercolour paper that needs to be strong and preferably slightly textured; cartridge paper is perfectly acceptable, however.

Watercolour techniques

Watercolour paint can be used in several ways, all of which involve control of the quantity of water employed.

Wet colours can be painted next to other wet colours and be allowed to gently bleed together, creating some unpredictable results.

Watercolour paints are translucent and can be painted on top of other colours once the first wash has dried thoroughly.

TRY IT YOURSELF

Using only a paintbrush and two colours - one light and one dark - draw a yellow tennis ball without the use of outlines. Allow five minutes.

Combining techniques

On this leaf, shapes such as the veins were emphasized by being left to show through as pure white paper. The other colours were allowed to bleed by letting wet paint run into wet paint.

green

Raw sienna

Yellow

Burnt sienna

umber

Ultramarine

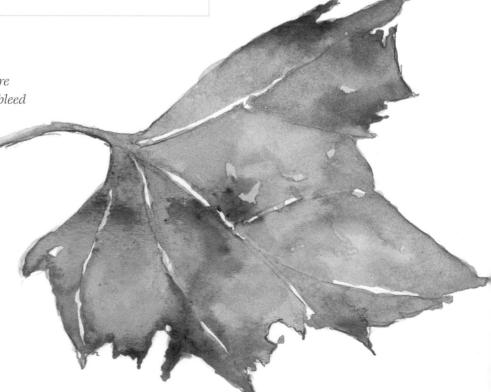

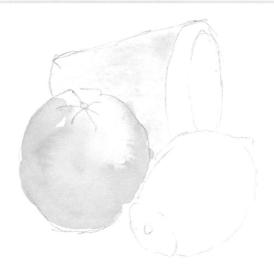

1 After creating the shapes by line drawing with a B pencil, wash the basic colours onto them.

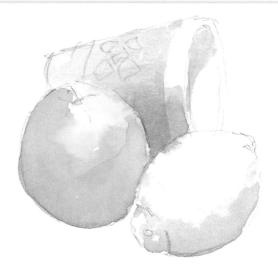

2 Next, mix a neutral yet warm grey from ultramarine, violet and a touch of orange, and use this to wash around the shapes of the shadows, creating a sense of curvature on all three objects.

Orange

Lemon yellow

Cobalt blue

Ultramarine

Violet

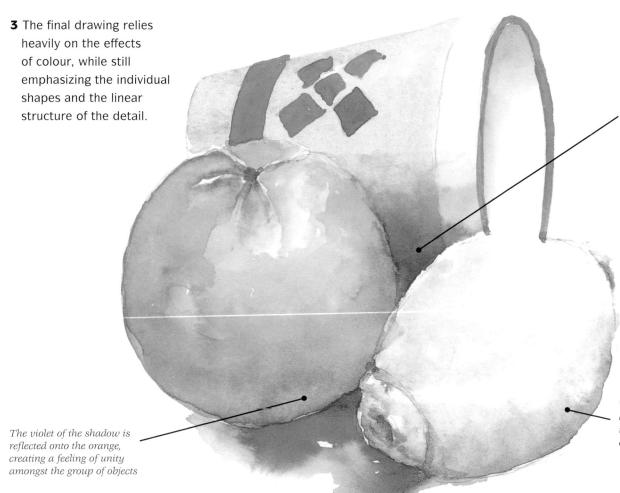

The central section was created by washing dark violet onto an already dark blue, to create a warm shadow

The texture created as colours run and bleed together can considerably enhance a drawing

Basic techniques

Most objects that we are likely to want to draw can be visually simplified into three basic shapes: cube, cone and sphere (plus any combination of these shapes).

Training yourself to see these shapes contained within your subjects makes it considerably easier for you to start to draw them, so they are worth practising when you have a spare moment or two. In addition, the whole idea of translating three-dimensional objects onto a two-dimensional surface can become easier by practising shading, looking carefully at where the highlights are on an object and at the corresponding shadows.

Spheres form the basis of many vegetables, such as onions and oranges, as well as vases, ornaments and even fishing paraphernalia. The highlight here is usually circular and can normally be seen towards the top, where natural light is reflected.

Cones can be found in objects such as watering cans, lampshades and party hats. Always look for the long, thin reflective highlight that is found on a curved surface.

The cube is the basis for objects as diverse as matchboxes, radios and garden sheds – only the scale differs. Unlike the two curved objects, a cube has clearly defined shading, usually light on top, medium tone on one side and a darker tone on the other visible side.

It really is a case of starting to view your subjects as part of a wider scene. You are unlikely to ever 'see' a bedside lamp as a cone balanced on top of a sphere – but if you can imagine how the lamp may look if it was constructed in such a way, then you will certainly find that this helps your drawing – especially in the early stages.

Studying light is also a valuable activity. Whilst writers and philosophers spend much time simply thinking, so artists spend much time just looking. The key is to mentally absorb what you see and be prepared to apply this to situations where you have to rely on your visual memory due to lack of appropriate lighting, for example.

Finally, once you have mastered the skill of visualizing everyday objects as being constructed from individual spheres, cones and cubes, start to seek combinations to develop your own personal 'toolbox'.

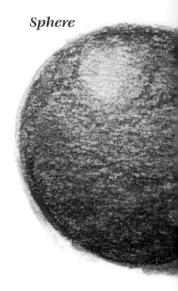

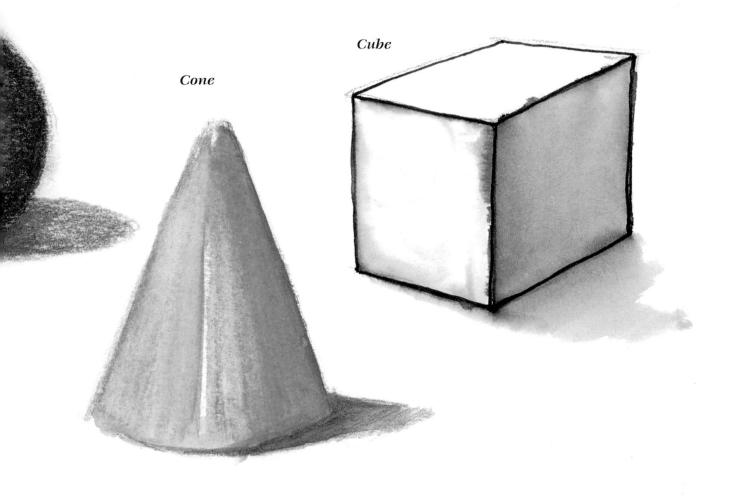

From cone to flowerpot

A cone can become the base shape for many objects, in this case, a flowerpot. Try to ensure that there are no points on the base: a smooth, unbroken line should curve round at the places where the straight lines meet it.

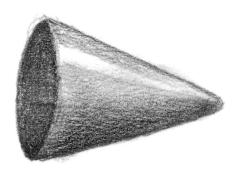

Next, start to construct the shape of the object that you wish to develop into a drawing around the base shape.

The base shape has now served its purpose and can be removed, leaving the 'moulded' shape of the flowerpot looking three-dimensional and thoroughly convincing.

Line

Line is one of the foremost instruments for artists to use: it is invariably the starting point of any drawing, and is often the only technique used in a picture.

Line is usually employed to establish the basic shape for your subject, but it can also be used to shade solid, hard-edged objects such as wooden blocks and shapes. Lighter shading can be achieved by varying the distance between the lines, and darker shading can be achieved by crosshatching. It is also possible to create detail such as wood grain or pattern by line drawing using a very sharp pencil.

Pencil

Pencil line drawing has one key requirement – a sharp pencil lead.

If you do not sharpen your pencil regularly you will end up with some thin and some fat pencil lines, which could cause confusion over which is the lightest and which the darkest shading.

Pen

Most pens create an even line, ensuring constancy within your drawing. The one disadvantage is that you may sometimes create a 'scratchy' surface as the pen nib catches and raises the surface of the paper.

Coloured pencils

Coloured pencils can provide a wide variety of tones in line drawing.

The key difference between this medium and others is that you might need to introduce more than one colour on the crosshatching side to deepen the tone.

Creating a wooden structure

Some objects, such as a wooden letter, can easily be constructed within a square or block, and are ideal for practising line drawing to create a basic shape. To help obtain symmetry, you may need to rationalize the basic block or square by halving it.

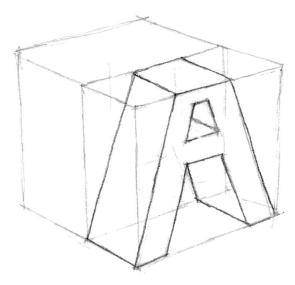

1 Draw the basic shape of the wooden letter; to ensure that the perspective is correct, you can lightly draw a box-type construction, as shown here.

2 Block in the basic colour by shading across the whole shape with a yellow ochre pencil, creating an even tone as a basis on top of which to work.

3 To establish the different tones, leave the side of the letter with the base colour showing. Darken the front by drawing over the face with the sharp tip of a raw sienna pencil, adding pressure for the inside sections.

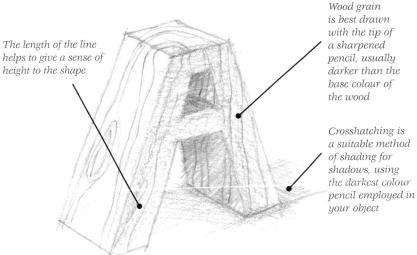

base colour of the wood Crosshatching is a suitable method of shading for shadows, using the darkest colour

4 Draw the lines of the wood grain onto the shape using the tip of a dark brown pencil, working on top of the previous two stages of the drawing.

Tone

As soon as you can create different tones within your drawings – that is, different degrees of dark and light within one particular colour – you will really begin to see your drawings come alive.

Different tones are usually created by either applying more or less pressure to your pencil, creating a greater coverage of graphite or coloured pigment; in the case of pen and ink, this can be done by increasing or decreasing the degree of dilution.

Spend as much time as you can in practising to see how many different tones of one colour you can achieve with as many different media as possible – this will pay dividends in time as your expertise increases.

Ink

The tonal range was created by washing plain water over an outline drawing made with a fibre-tip pen, using less water on the darker side and more on the lighter side.

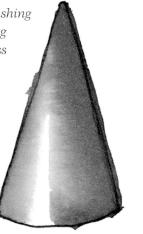

Watersoluble graphite pencil

The tones were mainly established before the water wash by pressing harder with the tip of the pencil to suggest darker tones. Once this was washed across, the darker shading still remained dark, if a little more fluid.

Pencil

The differentiation between the dark and light tones was created by using the edge of the pencil lead for the softer, lighter shading, and the tip for the stronger and darker tones.

Coloured pencil

Cone shapes can be the base shape for many objects, such as party hats. This illustration shows how to go about creating both tones and highlights.

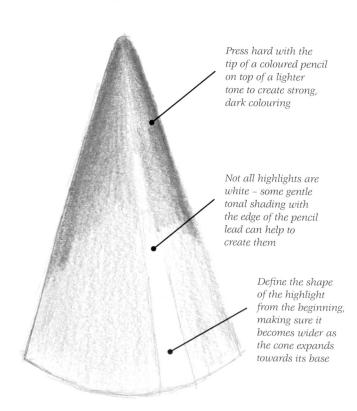

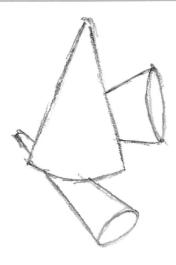

1 Create an outline drawing of three cones to represent the shapes of a small group of party hats with a sharp B pencil, creating different angles for each one. Keep the shapes simple at this initial stage.

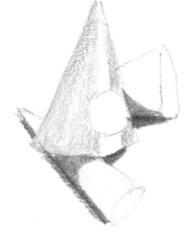

2 Add the base colour to each individual cone, remembering to leave the flash of light that runs along the cone to act as a highlight for each one. Then create a three-dimensional look by using a violet pencil to draw on the shapes of the shadows.

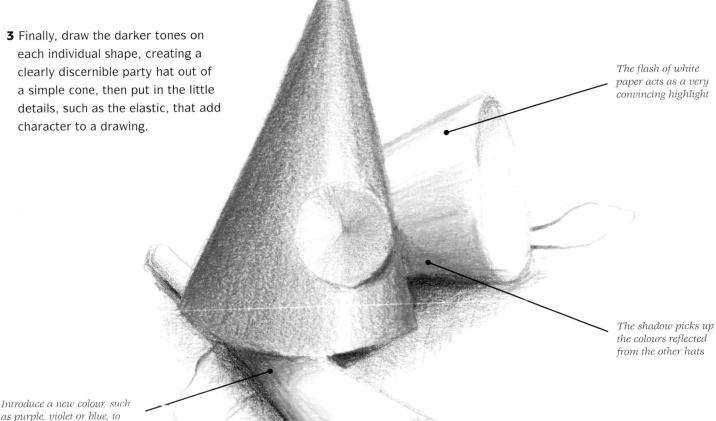

Introduce a new colour, such as purple, violet or blue, to emphasize specific shapes of strong colours

Light and shade

It is probably true that there is nothing more important in drawing than establishing a sense of light and shade – seeing where the lightest areas of your subject are and then matching them with the corresponding shading, leaving the middle tones to form the bulk of the object being drawn.

Usually the lightest part of any single object will be at the top, where the natural daylight or artificial indoor light will bounce from it, and the darkest areas will be towards the base, where access for the light is more restricted.

You can visually train yourself to look for these two key areas when you start to draw. Once you have done this, you will start to see just how easily the middle tones (those between the light and the shade) begin to take care of themselves.

pressure on the pencil when drawing around the bottom of the circle – this creates a darker tone. Then, using a soft paintbrush and clean water, wash around the ball, ensuring that the highlight is left untouched.

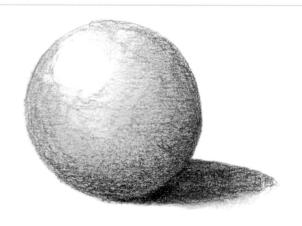

Pencil

Use the tip of your pencil to make a quick circular shape, then begin to create the tones by changing grip and using the edge of your pencil lead. Draw using a circular motion, applying greatest pressure at the base of the circle. Create the highlights towards the top of the ball to show from where the light is reflected.

Key shapes

A bedside lamp and shade can be created by using two of the key shapes – a cone and a sphere. Both reflect light, and both can be drawn using the same techniques as the ball.

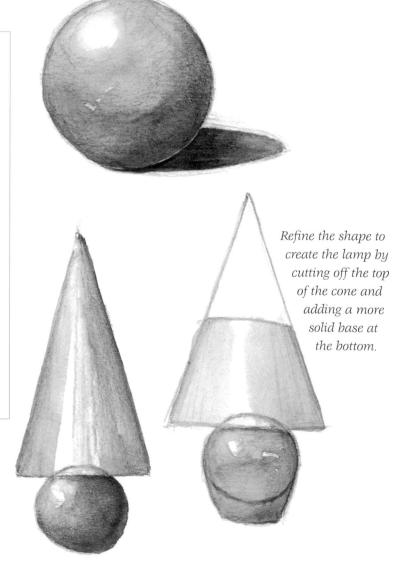

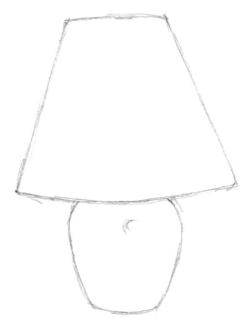

1 Having practised with a cone and sphere, it is easier to understand the visual relationship between the lamp and the considerably larger shade. Draw these as one object using line only.

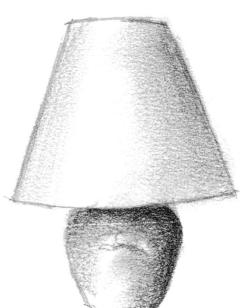

2 Look for highlights and begin to shade around these as you work on the lamp and shade, using the edge of your pencil lead and gradually adding more pressure towards the darkest sections.

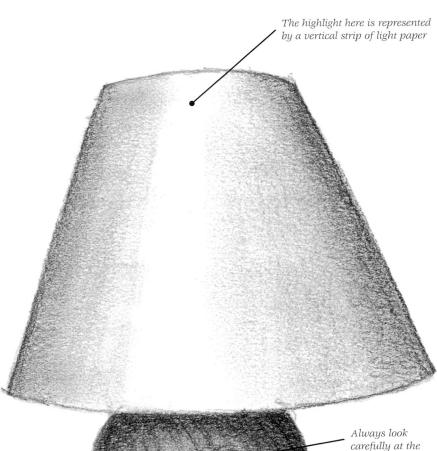

Lines drawn on top of tone can give detailed information about the nature of the subject **3** To turn a study into a real drawing add final details, such as wood grain or decorative patterns, using pure line-drawing techniques.

shape of the highlights – this is an arc shape

Positive and negative shapes

To create the 'push-pull' effect of making objects appear to come forwards when you draw them on a flat sheet of paper, you can place 'negative' shapes (usually shapes with little tone or colour) in front of shaded or coloured 'positive' shapes. Sometimes you can draw the background with a very dark tone to visually 'push' objects out into the middle or foreground.

This is the stage where you start to think as an artist – sometimes you will have to create areas of dark tone that you do not actually see in the scene in front of you. Doing this is necessary to create the backdrop for light shapes that need to be thrust into the foreground for the drawing to work.

Shading

An everyday item, such as a straining spoon, makes an ideal subject to practise on: the dark shading behind the spoon helps to make it look as if you could reach behind it, giving the drawing a three-dimensional feel.

Line drawing

Create the initial drawings as transparent shapes to give a better feel for the positioning of the objects.

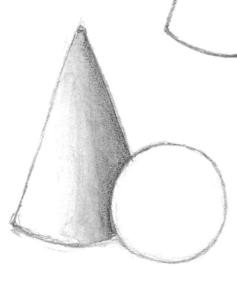

Negative foreground

As you begin to shade the cone, the sphere appears to be pushed forward towards you, making it a negative shape.

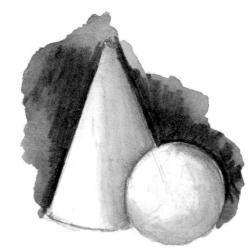

Negative foreground and middle ground

The addition of very dark shading behind the cone creates the feeling that both objects are being pushed forwards, towards the viewer.

1 Set up a group of kitchen utensils, leaving spaces in between them, and make a simple line drawing, examining the shapes created by the spaces in between the objects as well.

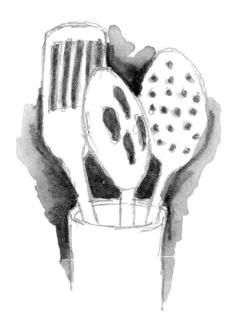

2 Next, shade 'behind' the objects, creating a dark backdrop against which these shiny objects can be viewed. Use a watersoluble graphite pencil to create a range of tones.

3 Add some subtle shading to the three objects, but not too much, as this may counterbalance the background and lose the positive and negative effect.

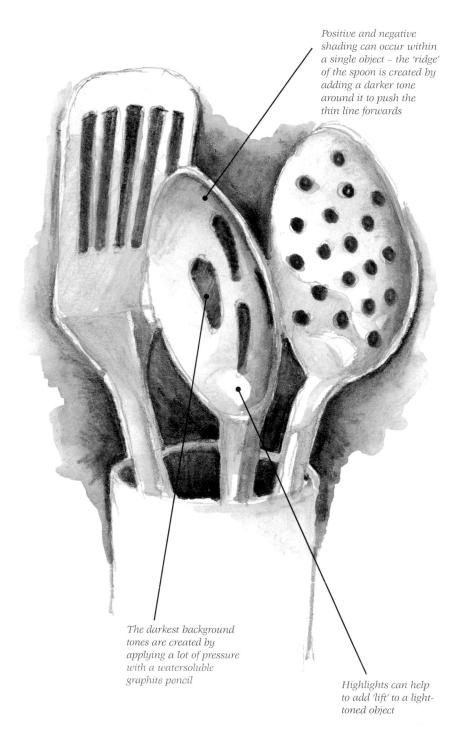

Measuring

When two or more objects are placed next to each other they can easily be used as comparative 'markers', using one to view the other against – how high one object is when viewed against the other, for example.

A number of judgements can be made at the initial sketching stage to help you to ensure that the objects in your drawing visually relate to each other, such as by checking the width and positioning on the surface of one object against another. This process can be made considerably easier if you continue to draw your objects as transparent shapes at first.

Cone and cube

Draw an imaginary line halfway down the main shape, and note exactly where the other shape sits in relation to this. Is it higher or lower?

Now check both vertical and horizontal planes to ensure that both objects are of the correct relative size, height and width. Now you can begin to develop the study.

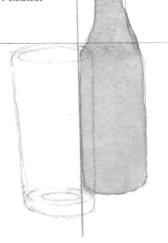

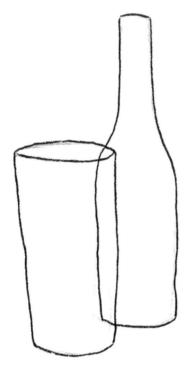

1 For extra solidity within this simple two-object composition, I used a fine-line ink pen. After checking the measurements, the first stage is to create a simple line drawing.

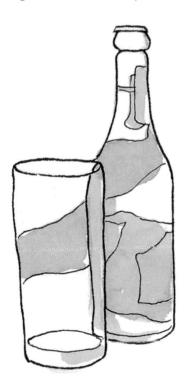

2 Next, look for the main shapes, either through the glass or reflected from it. Then, with a watery mixture of diluted Indian ink, wash in the shapes to begin to develop the drawing.

3 Vary the depth of tone of the ink as you continue to look for shapes through the glass and bottle. You can create the reflections by leaving areas of pure white paper.

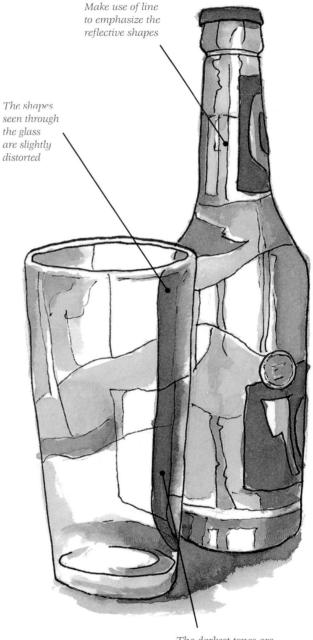

The darkest tones are created by using barely diluted Indian ink

Format

There are no rules of art that have to be obeyed: many conventions have grown up over centuries and are sound guidelines to follow – but they are not obligatory. So there is no format in which particular subjects have to be drawn. Traditionally, seascapes are long, thin and horizontal – but why not try drawing a vertical seascape? The effect can be dynamic!

There are three main formats that are traditionally used: portrait (upright), square and landscape (sideways). On the page opposite I have taken one subject – a pair of cowboy boots I collected in Colorado, USA – and have drawn it in the three different formats, adjusting the composition to fit each one.

Portrait

The portrait format will always give your subject a sense of height, but can result in a little too much space being left at the top if you are not careful, pulling the viewer's eye down to settle at the base.

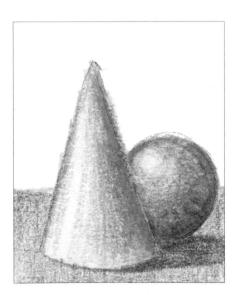

TRY IT YOURSELF

Make two drawings of a selection of pencils – one of them standing in a pot, and one of them lying flat on a surface. Allow ten minutes.

Square

This is a less popular format than the other two as it lends a geometric equality to the picture frame, forcing you to look straight into the centre, with no space for your eye to travel out of the picture frame.

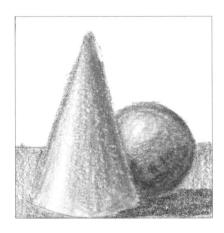

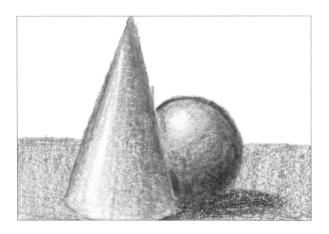

Landscape

This format encourages the viewer's eye to move from left to right (the way we learned to read), stopping only at the objects in the centre. You may end up chopping off the top or bottom if you misjudge the height of your subject.

Choosing a format

The landscape format suited the way in which the boots had fallen, one across the other. While they have not filled the picture frame, they appear to have more length than height.

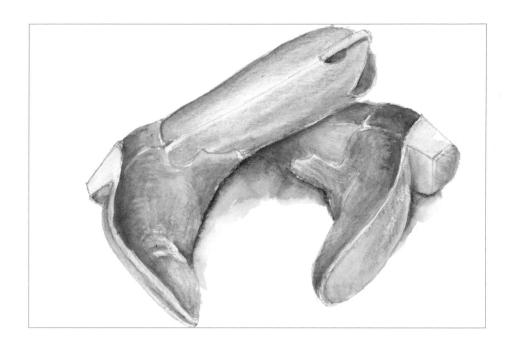

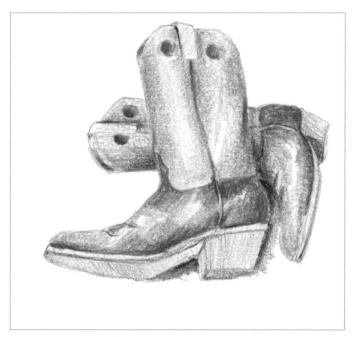

I rearranged the boots to fit them into the more difficult square format. Drawn within this box they have a more 'compressed' feel, lacking visual space around them.

> When I stood the boots upright, it instantly seemed obvious that they would sit happily within a portrait format. Their height draws the viewer's eye from top to bottom, leading out of the picture frame as it follows the toe pointing towards the bottom right-hand corner.

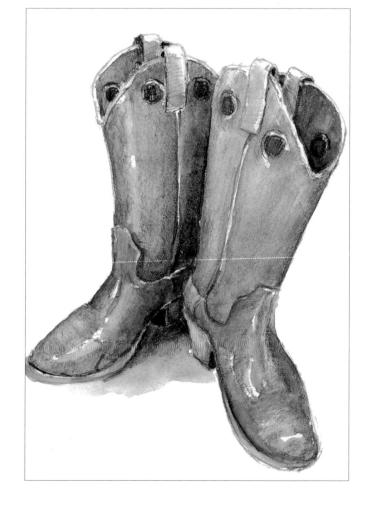

Tabletop perspective

The traditional 'rules' of perspective dictate that parallel lines should be drawn as if they would converge to meet on one point on the horizon. On a tabletop, however, there is no horizon, so you have to imagine that parallel lines would eventually meet, and arrange them to converge slightly.

In reality, this means that any square or rectangular object you draw will appear to be only slightly smaller at the end that is furthest away from you. This allows you to draw three-dimensional objects on a two-dimensional surface in a convincing way – in fact, you can even draw cylindrical objects in this way, fitting them into a rectangular shape at the sketching stage.

Shading a cube

Having created a good three-dimensional illusion (which is what drawing in perspective is), look at the different degrees of shading that can be seen.

Cube angles

When you draw a cube, extend the lines so that you can detect a slight degree of convergence.

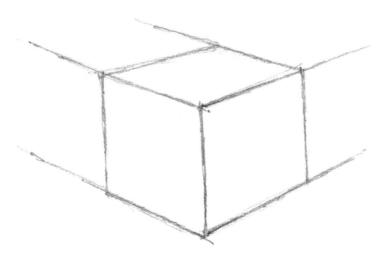

Try twisting a cube around to see how the different planes appear to converge in order for your drawing to look convincing.

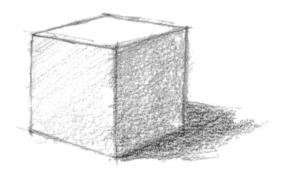

STEP-BY-STEP EXERCISE

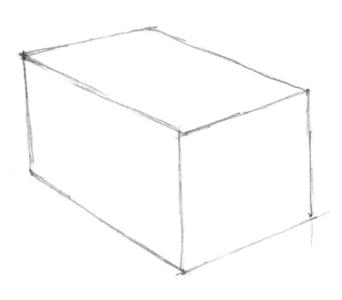

1 Visualize your subject contained inside a crate and draw a rectangle of an appropriate size and shape, ensuring that the lines converge a little.

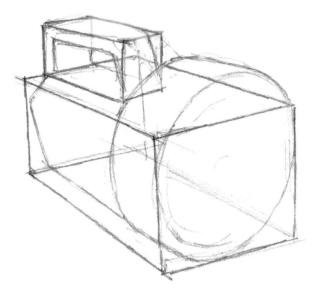

2 Next, draw the basic shape within the crate, allowing it to break free where appropriate. This 'crating' technique will ensure that, however complicated your subject, it will be in correct perspective.

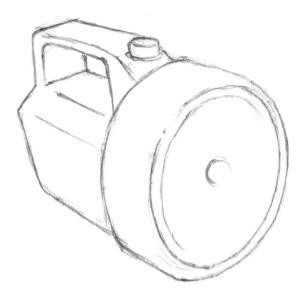

3 The next stage is to remove the perspective crate guidelines with a kneaded eraser, and to treat the subject as a normal drawing by adding curves and details as they become necessary.

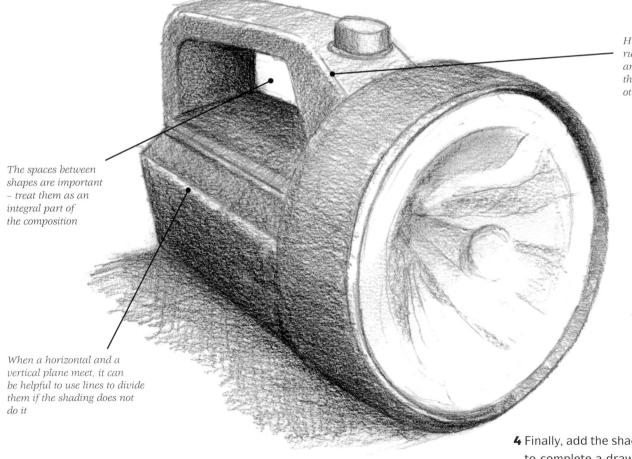

Highlights follow the rules of perspective and converge along the same lines as the other shapes

4 Finally, add the shading and shadows to complete a drawing that started off as a simple rectangular crate.

Indoor drawing: Saturday

As you begin to select subjects to draw, you will need to make some judgements about exactly how long you will need to give to the task. This is not necessarily bad: while spontaneity in drawing is highly desirable, planning can help you to achieve a given task within a certain time, so you don't have to leave a small drawing incomplete due to other commitments. This is easy to do when drawing indoors, as the subjects are usually those that you have selected and positioned, and you are in charge of the process.

Your choice of subject will vary according to your confidence. Always start off with the simplest of subjects, as this can only serve to improve your confidence, and with each success you will be fired to move on to the next stage. But rigidly following any programme of instruction can, in itself, be a little restrictive, so try to expand your own boundaries. For example, once you feel confident in drawing and shading a box, find a matchbox to draw. Then try a small cereal box, choosing exactly how much of the decorative logo you include, before moving on to a shoebox with a pair of shoes in it.

The other great advantage of indoor drawing is that you can control the lighting. If you want soft, gentle shading with only the hint of a shadow, you can place your subject by a window on a dull day; however, if you are exploring the qualities of shadows and how they can help to define the shapes of objects, you may decide to place them close to a table lamp, perhaps removing the lampshade to create a more intense light source.

Finally, consider perspective. Outside, the rules of perspective are clear – all lines appear to converge to a point, or points, on the horizon, and all other lines fit into this structure. Indoors, however, you will not have a clearly visible horizon. For this reason, the following pages refer to the tabletop perspective explored on pages 32–33. This involves developing a feeling (that eventually should become intuitive) for converging lines. All objects, even within the space of a tabletop, need to be drawn as if they are a little smaller at their farthest end than they appear at the end nearest to you.

To demonstrate this, look at a rectangular placement set down on a table in front of you. If you drew it as a perfect rectangle (which it may well be) it would look as if it was standing up. By making sure that the two side lines converge slightly, you are introducing an element of perspective, making it appear to be sitting flat on the table surface. Try to observe these features rather than trying to construct them by a complex series of perspective lines; and this is where we started this section: a little planning is a good thing, but it cannot fully replace spontaneity and intuitiveness.

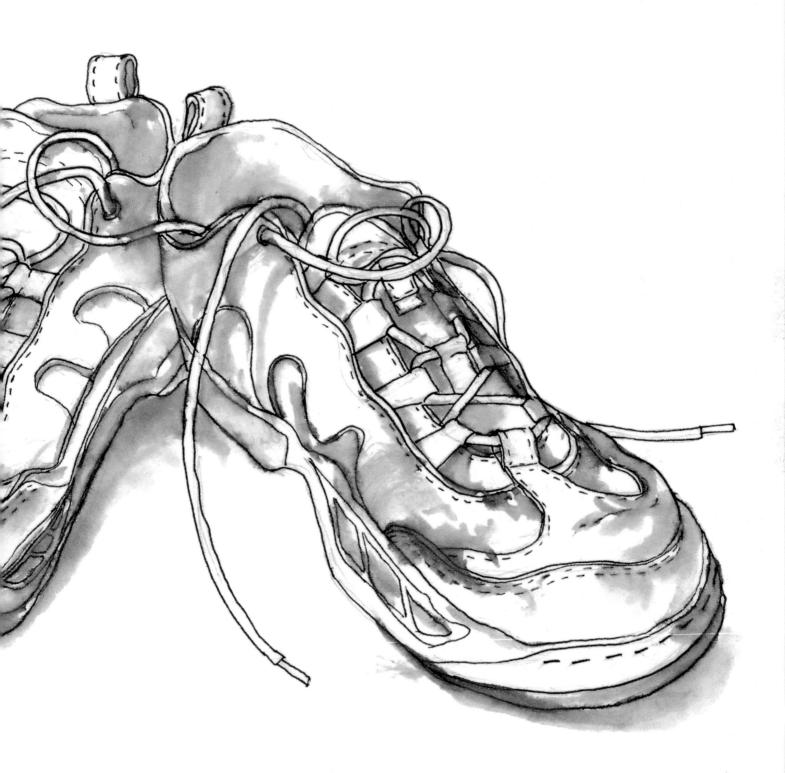

Round objects

Round, circular or spherical objects abound in most homes - mugs, glasses and containers of any sort make good subjects, whether opaque or transparent.

The key when drawing round objects is to avoid creating points by trying to join two semicircles to create a circle or oval – practise drawing circles and oval shapes in one fluid sweep. making them join imperceptibly.

Shading on curved surfaces is usually graduated – that is, it gradually changes from dark to light. This is a technique best practised using the edge of a pencil lead.

Thin to thick

The natural response to drawing a circular object is to draw the upper and lower circles and then join them with a line. This, however, will create a paper-thin image.

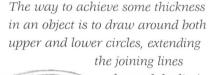

beyond the limit of the circles and thus giving a degree of substance to the drawing.

STEP-BY-STEP EXERCISE

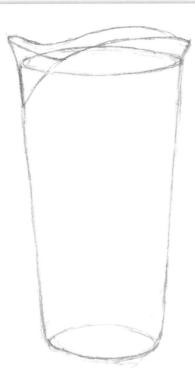

1 Build the shape of a decorative vase around an upright cylinder, only adding the shaped lip at this stage.

2 Next, add the base circle, still viewing the entire object as transparent, so that you can judge exactly how much of the base to show.

TRY IT YOURSELF

Place a white cup or jug on a surface. Shade and draw around the outside of the objects to create their shapes, without letting your pencil 'touch' the objects themselves. Allow ten minutes.

3 You can then apply a simple watercolour wash to introduce both colour and form. Once this has dried, pick out the pattern using the tip of a fine brush.

The inner shading
of the vase is shaded
using grey watercolour
paint, leaving a light
lip running around the
top of the vase as
a negative shape.

The bottom of the vase is painted using the darkest tone; when using watercolour paints, always mix the colour for these sections with less water

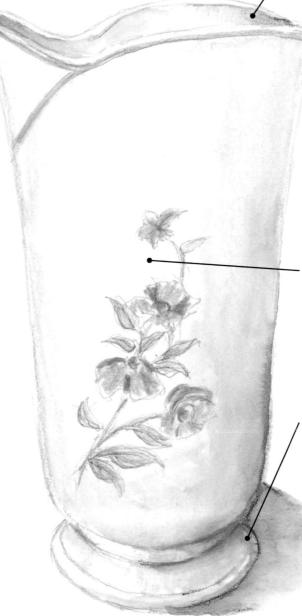

Shading on round objects

The way in which light falls onto objects, creating highlights, middle tones and, ultimately, shadows, is an important area of study for artists.

Round objects invariably show graduated shading as the light falls onto their surface and gradually fades to dark. Without any sharp angles there are no hard-edged shadows to be seen, leaving only smooth, gentle toning to draw. It is worth studying round shapes that you can see into. allowing you to create a sense of thickness within your drawing.

Inside and outside

Having constructed a hollow tube from a cylindrical shape, look at the shading inside and gradually change the tone from dark to light as you draw the shadows cast inside.

Next, observe the shading on the opposite side, where the shadow on the outside of the tube changes from light to dark, creating a threedimensional shape.

STEP-BY-STEP EXERCISE

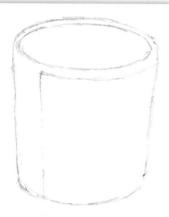

1 To draw an everyday kitchen mug, start with a short cylindrical shape and draw an oval shape inside to create a sense of space.

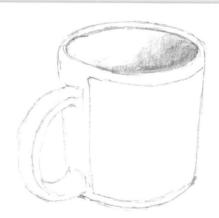

2 Next, add detail such as the handle. Then observe the shading inside the mug, and record the tone and the curve of the shadows.

3 Complete the drawing by adding the corresponding shading onto the far side of the mug, followed by the shadow it casts onto the tabletop.

Look for the darkest shading in the deeper part of the mug

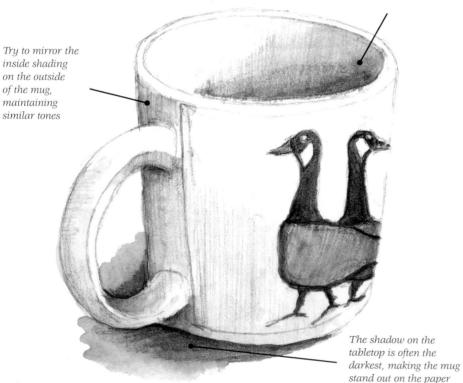

1 Start drawing a decorative jug as a sphere, adding the tip and handle in the initial sketching stage.

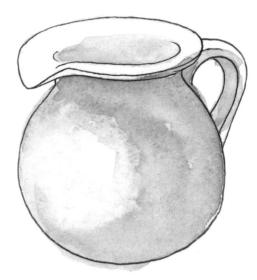

2 Next, using watercolour, wash a light blue tone around the shape, leaving a light spot where the light rebounds. Shade inside the jug with the same paint.

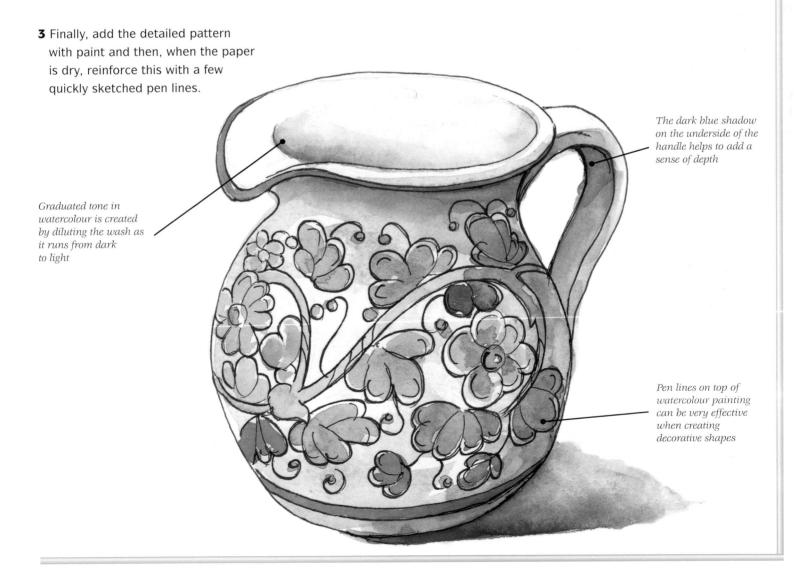

Shadows on round objects

Whenever you have a source of light, you will have a shadow - maybe not a strong one, but nevertheless a shadow. As artists, we see more than others because we know how and where to look

Whenever you see an object that you plan to draw, always look at the base first, to see both the shape and the depth of tone in the shadows cast – some objects will cast a simple shadow, either hard-edged or graduated, while more complex groups will cast shadows that require you to draw specific-shaped shadows.

It is also worth closely observing the colour in shadows: you will always find a little of the colour of the subject reflected in the shadow.

Light shadows

The shadow cast by this candle is small, graduated and light - not immediately noticeable, but significant to visually anchor the candle to the tabletop.

Cast shadows

This cricket ball was drawn with a B grade pencil and then washed with watercolour paint. The shadow was created by adding a strong blue paint to the red of the ball to recreate the effect of reflected colour.

> Inside shadows can be drawn successfully with a 6B pencil

in this study

Dark shadows

The shadows cast by this group of stacked flower pots are a major part of the study, especially as they are darker in tone than the pots themselves.

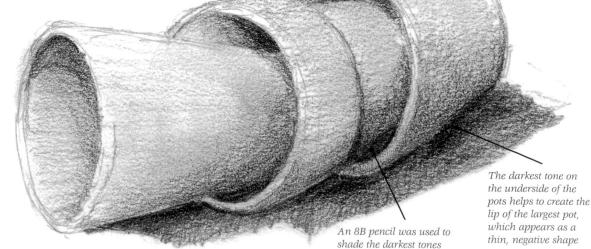

1 Draw the pestle and mortar initially with a 2B pencil, paying particular attention to the curved shapes.

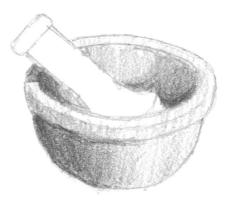

2 Next, use a terracotta coloured pencil to add colour and tone to the mortar, applying more pressure to the darker areas and barely touching the paper with the pencil around the rim.

TRY IT YOURSELF

Place a decorative object, such as a candlestick, in front of a well-lit window and draw the shadow as you see it, creating a negative shape of the object. Allow ten minutes.

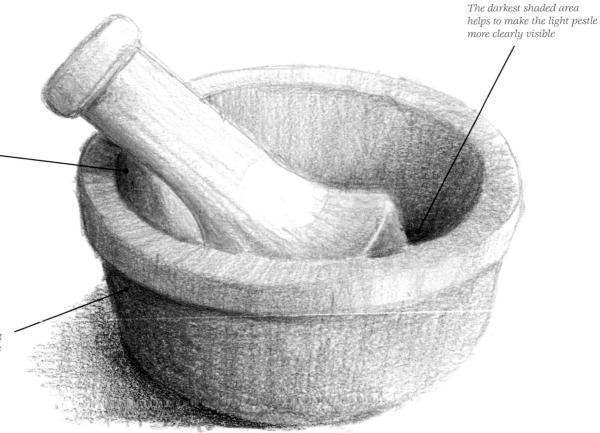

The darkest shadows are created by working on top of the terracotta pencil with a dark brown coloured pencil

The shape of the shadow curves as it falls on the round surface of the mortar, helping to provide a sense of roundness to the drawing

3 In the final drawing, explore any shadows cast inside the mortar as well as on the tabletop.

This makes for a much more interesting composition.

Transparency and reflections

Although drawing glass of any sort usually terrifies most beginners, it can easily be mastered using just a few media-specific techniques.

As glass is, by its very nature, transparent, you will usually be able to see through it, forcing you to draw what you see through or inside the glass, not the glass itself. In some cases this will involve a certain level of visual distortion.

Glass also reflects light, which is best represented by drawing around a few key shapes to suggest the light then shading around these shapes, leaving a few selective flashes of pure white paper.

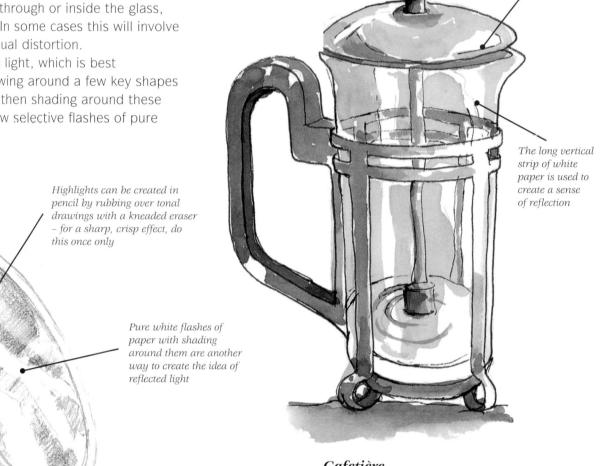

Mirror

Objects such as this mirror seem be intimidating, but need not be. The structure is circular, and the reflections are created by judicious use of tone and highlights.

Cafetière

This pen and ink drawing relies on the combination of solid line and subtle washes. The shapes viewed through the glass were drawn with a slight 'wobble' to create the sense of distortion that glass often gives, and the highlights were drawn in from the very start.

The shape of the highlights reflects the

curved shape of the lid

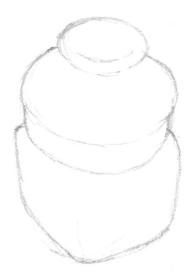

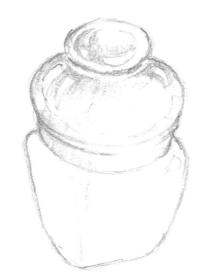

2 Next, study the glass jar carefully to see exactly where the highlights are and then sketch them onto the jar as negative shapes. Use the edge of a 4B pencil to shade around them.

Some of the reflective shapes circled the lid, only varying in width in places

1 This jar, observed from a fairly high view point, really consists of a square base with rounded corners and a circular lid. Create the initial line drawing around the shapes using

a 2B pencil.

Reflective shapes cut across the sweets – these are drawn 'behind' the glass

3 This drawing relies heavily upon the interplay of light and shade, which is captured on paper by the use of negative shapes and flashes of white paper to represent light bouncing from the glass. This drawing technique is simple yet highly effective to use.

The sweets are drawn using coloured pencils, darkened towards the bottom using a 6B graphite pencil

PROJECT: Distortion through glass

As with many of the best ideas, this project came about by accident. During a break I noticed that an empty glass placed on top of a newspaper gives the print a whole new dimension – the distortion through the glass allows the lettering to take on a new form and still be recognizable.

I used watersoluble graphite pencil for this drawing, as the range of grey tones far outweighed the few solid blacks that could be seen. I also felt that the fluidity of the wash would help to create the smooth effect required for the glass.

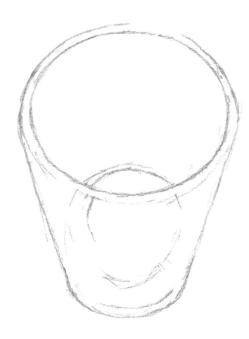

1 The first stage is to create the structure of the glass, using the technique of drawing two circles and the top and bottom and joining them up, ensuring that a lip is left for the rim of the glass.

2 The next stage is to explore the way in which the glass breaks up the flow of the headline lettering. Begin the shading process at this stage to add an element of solidity to the developing drawing.

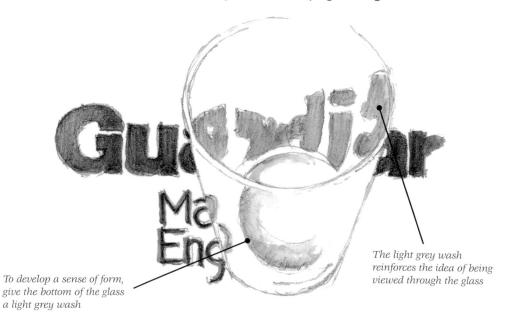

3 Observing carefully the distortion of the lettering seen through the glass, begin to draw the shapes created. It is important to create the diffusion of tone observed through the glass by ensuring that the lettering here is a slightly lighter tone to that on the outside of the glass.

Ensure that the tonal differences between the letters outside and those viewed through the glass are noticeable – this helps to reinforce a sense of transparency

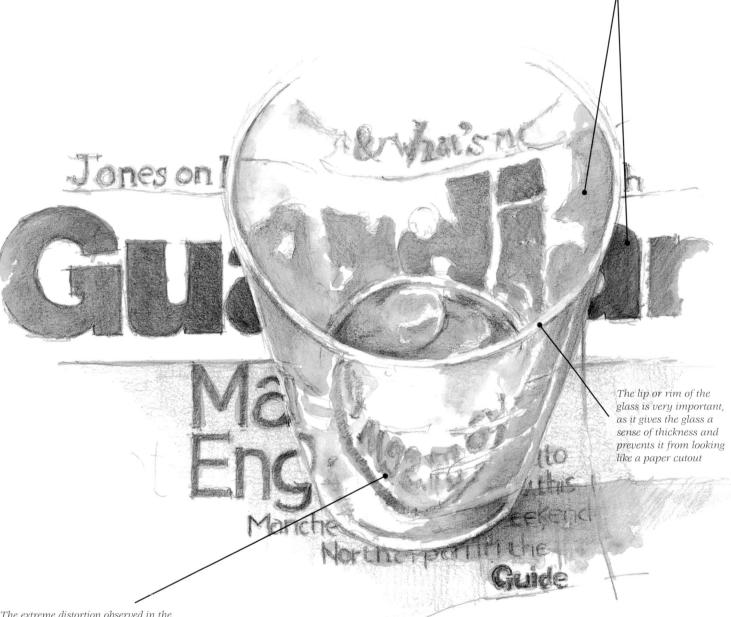

The extreme distortion observed in the bottom of the glass is, in fact, barely recognizable letters. This adds to the appeal of this unusual subject

4 To finish the picture, add more detail by way of careful observation of the lettering both inside and outside the glass. Of course, you can stop at stage 3 and still be pleased with the drawing created, but adding a few words and some more tones can create a fascinating image.

Rectangular objects

We are surrounded in our everyday lives by objects that can be created out of a basic rectangular shape: suitcases, radios, cereal boxes and books can all make excellent subjects for drawing and are all essentially rectangular in shape.

Once you have spent a little time practising the tabletop perspective skills, you will soon become adept at drawing a variety of simple rectangles. This is the point at which you start to add elements of interest by lifting lids, opening boxes and even looking inside to draw some contents. Finally, although the temptation may well be to draw some lines with a hardedged object such as a ruler, resist this at all costs, as it will only look unnatural!

Without ends

Sometimes you will not see the front or back end of your object. In this particular drawing, I have slightly exaggerated the convergence of the side lines to develop a sense of depth within the box.

I simply moved the lid to create a whole new shape with much more interesting shadows.

Angles

If the end of a rectangle is facing you head-on, the shape is likely to be drawn as a solid, geometric square. Remembering tabletop perspective, draw the other two visible sides converging slightly.

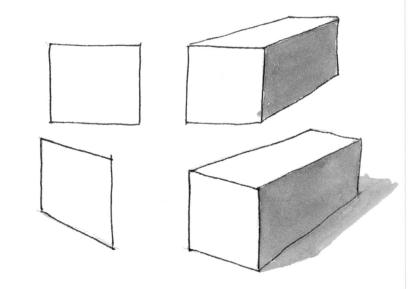

If, however, the object is set at an angle, the lines of the front end of the rectangle will appear to converge along with the other sides.

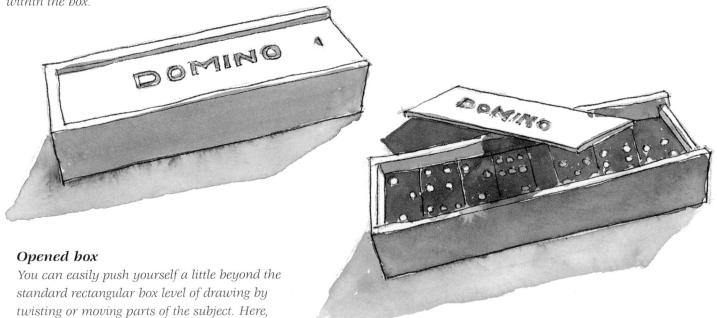

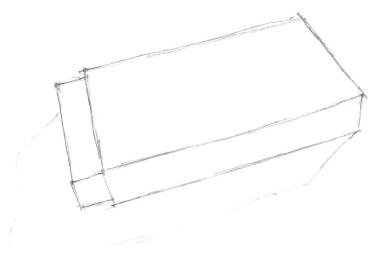

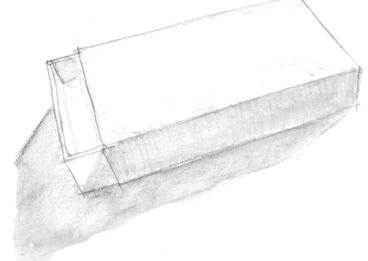

1 The first stage is to create a line drawing of the most basic shape, positioned at the same angle as the domino box, ensuring that the shadow shape is included.

a simple subject

2 Next, pick out the shapes that define the inside of the matchbox and then apply a thin watercolour wash, ensuring that both the inside of the box and the facing edge are darker than the rest.

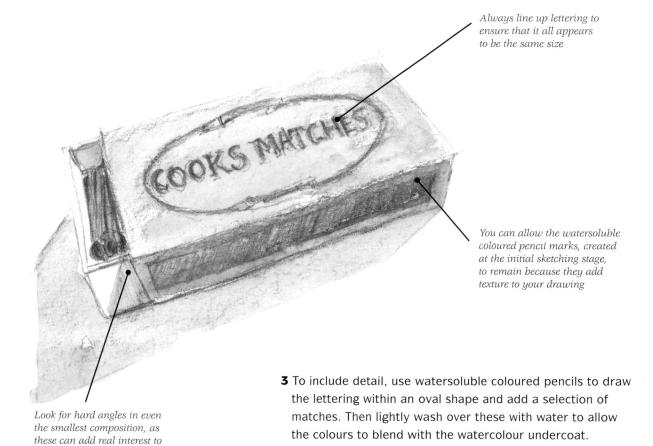

Shading on rectangular objects

In or on most objects you will find at least three degrees of shading – the highlights where the light catches and reflects, the darkest tones where little light reaches, and the middle tones that fall in between.

On spherical objects this shading will always be graduated; on rectangular objects the shading is much more likely to be defined by hard edges. This does not mean, however, that you will not find a mixture of tones within the flat planes of a rectangular shape, but the hard edge will always be there.

While all media are suitable for practising shading with hard edges, you may get started more easily with a solid medium such as a pencil.

Basic cube shape

The initial stage of creating any cubic or rectangular shape is to make sure that both sides appear to converge, giving a three-dimensional look.

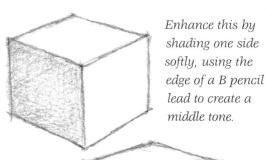

Apply more pressure to create a much darker tone on the shaded side and then add the shadow. All these stages help to create the illusion of a three-dimensional object on a two-dimensional surface.

Empty box

An empty box can provide a good starting point for shadow drawing.

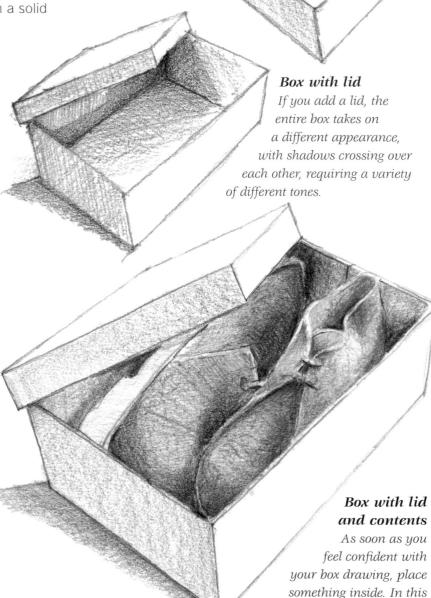

drawing, note how I have used

in the shadows.

the colour reflected from the shoes

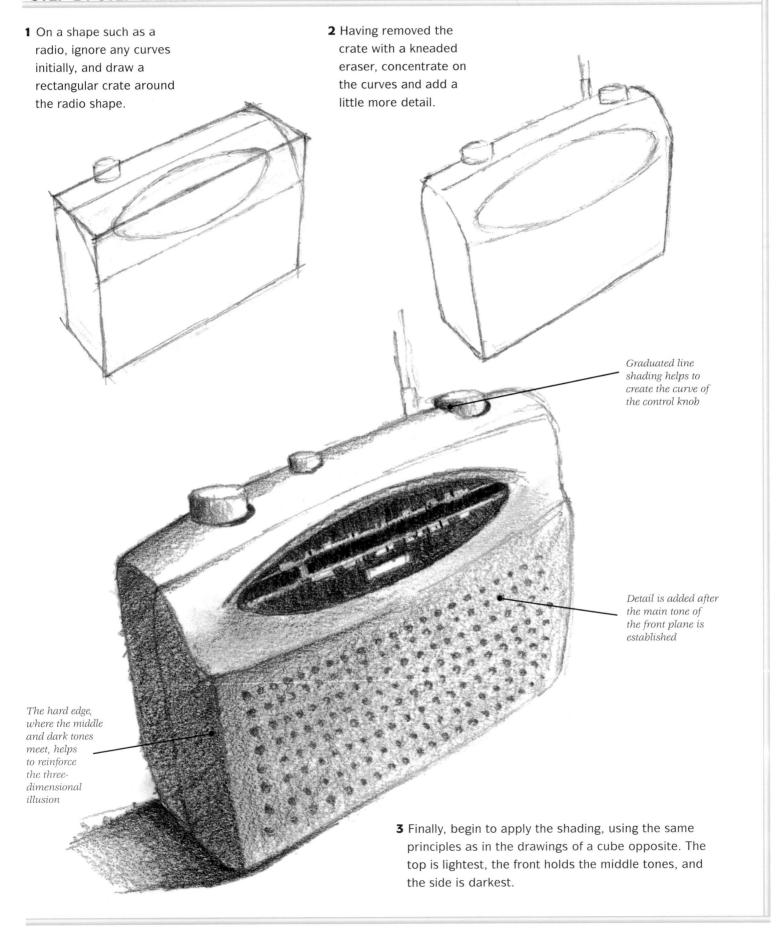

Shadows on rectangular objects

Shadows are crucial elements which, included in even the smallest of drawings, help to visually anchor objects to a surface. Without shadows it may look as if your subjects and the surface on which they sit are disconnected.

Shadows take on many forms: they may be hard-edged and solid or soft-edged and graduated. But whatever the type of shadow, they can all be recorded in all media.

Shadows, however, are not only to be found on table tops or horizontal surfaces. They are cast from all objects and can help to define the shapes of the objects onto which they fall, changing their visual identity and making them all the more interesting subjects to draw.

Books

Using a fibre-tip pen, I drew the basic shapes of this pile of books and then gave the group a three-dimensional feeling by washing across the drawing along the lines of the shadows with a soft wet brush.

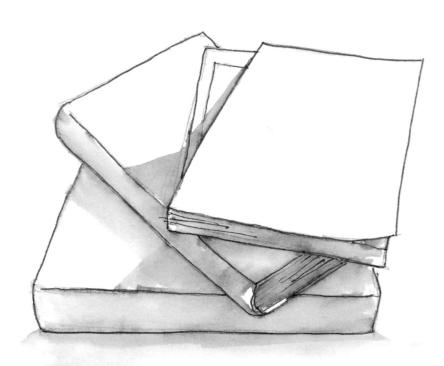

STEP-BY-STEP EXERCISE

1 Create a small group of objects, such as books and packs of cards. Use a B grade pencil to create an outline drawing, remembering to use perspective and ensuring that the box shapes appear to recede a little.

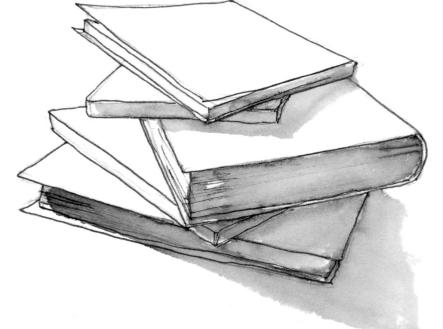

As I turned the group around, the spines faced away and the pages became the centre of interest. Having drawn the new shapes and washed in the shadows, I then picked out a few of the pages with the tip of the pen.

2 Look carefully to see exactly how the shadows fall across the group, then use a grey colouring pencil to block in the shapes and create shadows.

TRY IT YOURSELF

Pile up three or four books by a window, creating strong shadows.

Change the angle of the group and draw it from several different positions, using a different medium for each drawing. Allow 20 minutes.

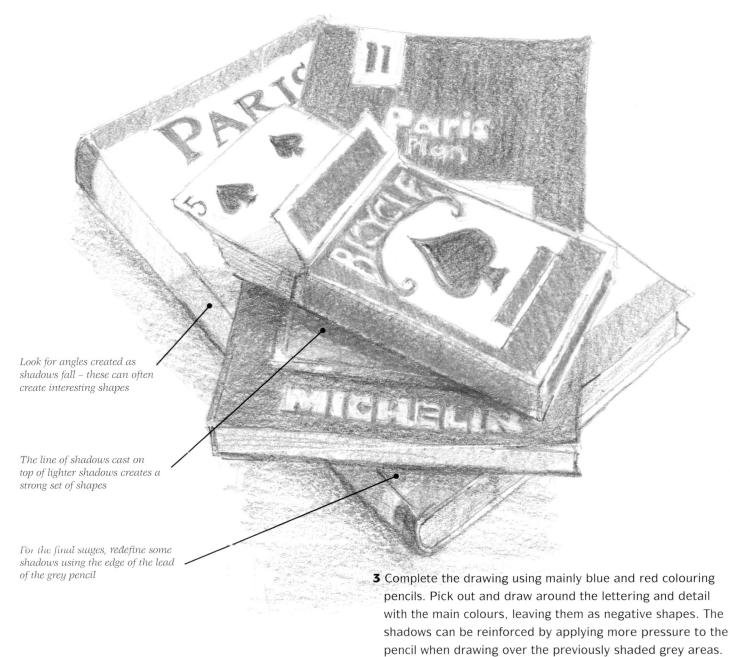

Adding detail

Once you have mastered drawing rectangular objects and achieving the three key shades, you will want to look beyond the basics and seek some subjects where you have to look more carefully at the detail.

Choosing a subject for detail means making a number of choices, the main one being just how much detail to add. My recommendation is to avoid anything with a lot of detailed lettering – large lettering can usually be blocked into a specific shape, or even drawn individually, but you should start with an object in which you can clearly identify general shapes with which you are already familiar, such as circles or squares.

Different details

Having practised drawing regular rectangular objects, experiment with something unusual. This chocolate bar contains smaller rectangles within one rectangular shape, and the wrapper provides the opportunity to practise adding detail.

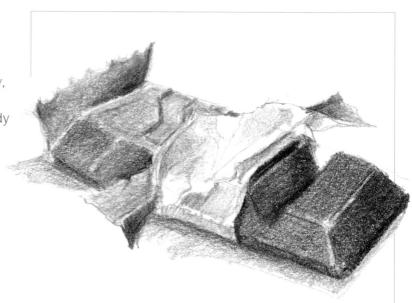

From box to camera

rectangular shapes, you can begin to create a wealth of drawings simply by adding details. Start with a basic shape.

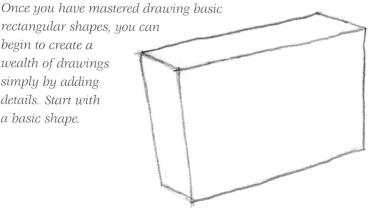

Then, using shading (in this case, with a watersoluble graphite pencil), begin to develop the detail through the build-up of tones and the addition of a few extra shapes to define the detail.

The next stage is to add the main shapes to the rectangle, thus beginning to develop a sense of identity.

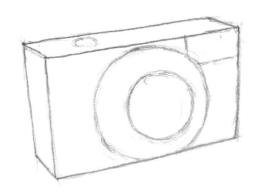

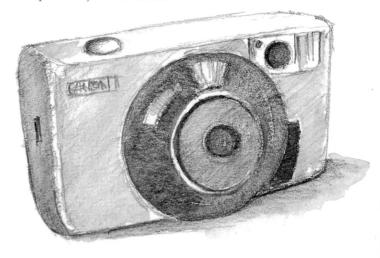

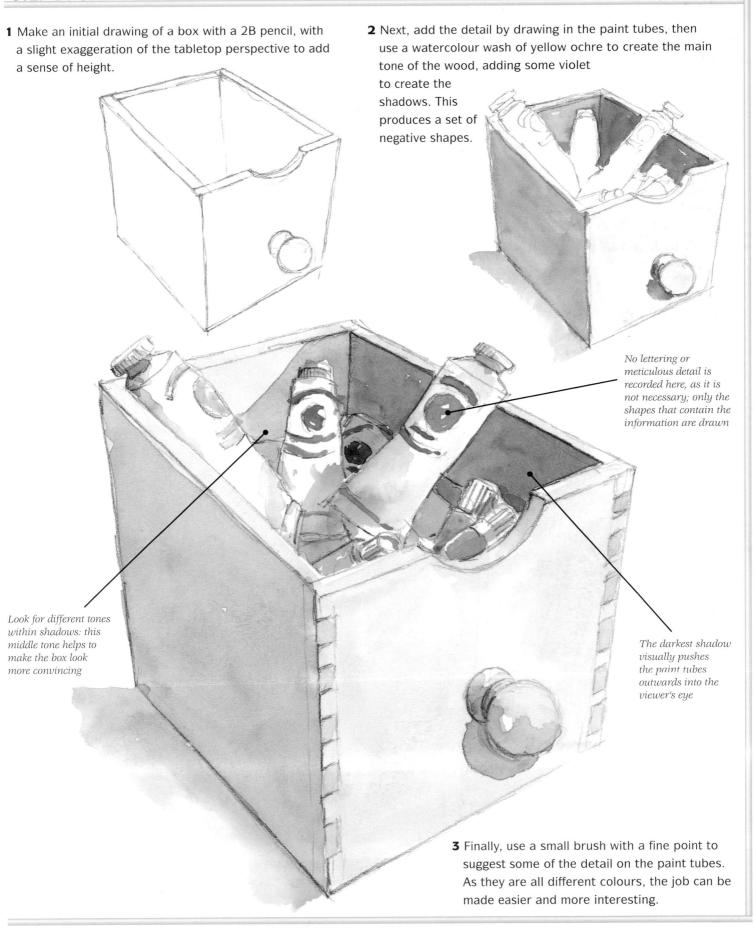

PROJECT: Open briefcase

Most of us have, at some time in our lives, used a case, bag or satchel to carry our things to school, college or work. So why not use this receptacle for practising some recreational drawing and explore it from a visual angle? A briefcase, for example, has sharp edges to contrast with the softer edges of the contents.

This drawing is, at its most basic, two rectangles or thin boxes – one horizontal box and a vertical box joined to it by a strip of leather and a few hinges that cannot be seen. Given this. I found it more interesting to look at the contents of the case - the sort of everyday objects that we use frequently, but rarely observe as subjects for drawing.

1 The key aspect of this drawing is to explore the way in which the contents of the briefcase work together. To begin this exploration, start by drawing the two key objects as rectangular blocks set against the outline of the creased newspaper.

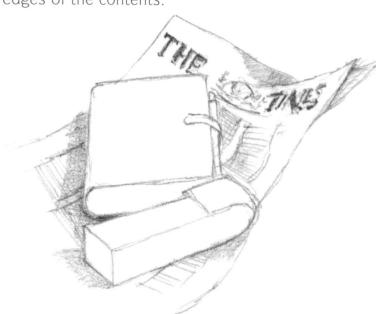

2 Next, using the edge of a 2B pencil lead, softly apply the shadows to enable a better view of the main objects, which stand out more against a darker background. You can round off the edges, creating more clearly defined and recognizable shapes.

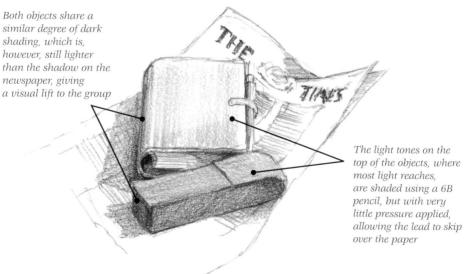

3 Now you can begin to explore the shading, looking to create three different tones – light, middle and dark – on each object. Use a 6B pencil to create all the tones on the diary and spectacle case.

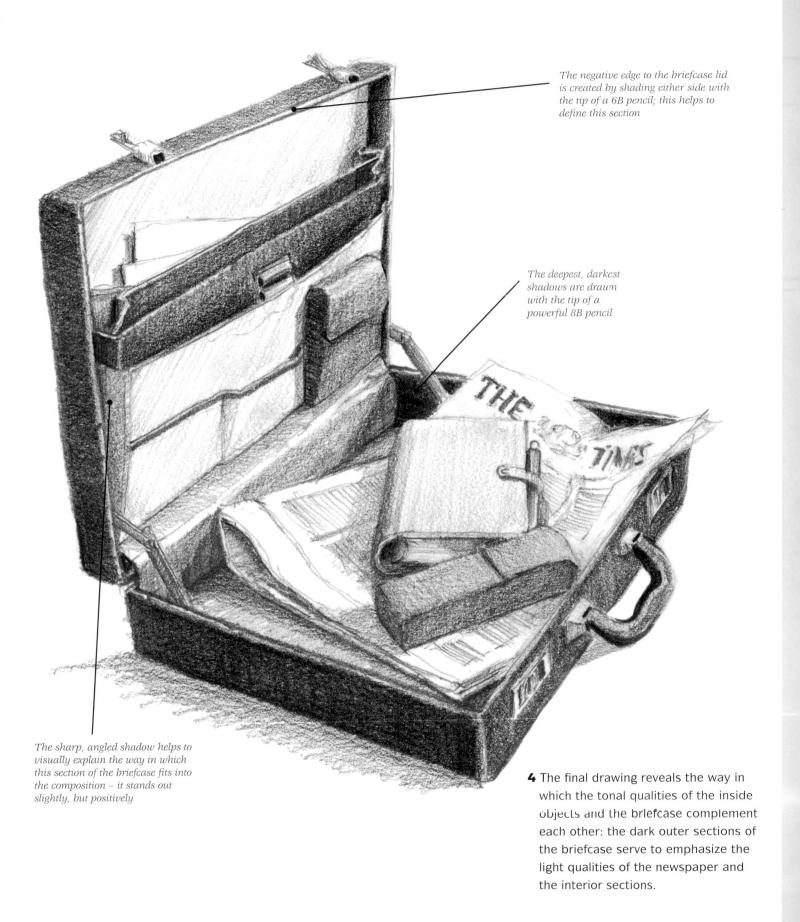

Still life

Having spent time practising drawing round and spherical objects, then rectangular subjects, it is now time to explore the way in which these can be placed together to create a still-life group.

The term 'still life' refers to any group of objects that you choose to place together, which will not move of their own accord – so there are absolutely no limits at all on what you can choose to draw.

As always, start with simple objects before moving on to more complex ones, but do not just stick with the basics – you will soon become tired of simplicity.

Bucket and spade

This drawing begins by constructing the bucket from a basic cylindrical (conical) shape, followed by the spade, which is created by fitting three rectangular shapes together.

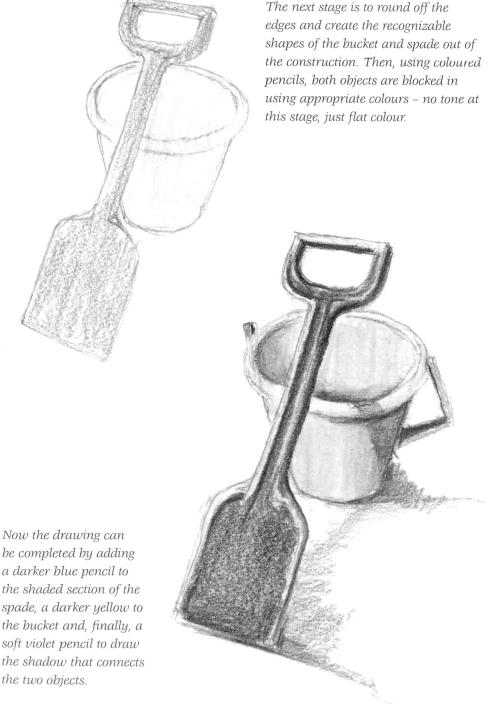

1 Use cylinders and cones to achieve the best shape of the binoculars by initially drawing them as transparent shapes to gauge their position on the books. Draw the books as rectangles.

2 Next, turn the construction drawing into a more identifiable image by adding the detailed sections and removing the construction lines.

ideal for this

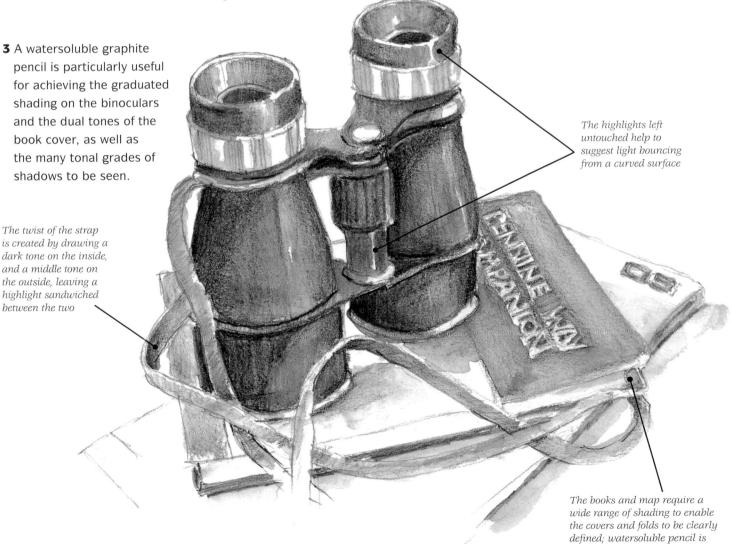

Shading on still lifes

Shadows and shading are integral to any group of objects – even on the dullest day you will find shadows cast onto the surface on which they are placed. The key, however, is in learning to combine the shading on your subject and the shadows cast from it.

While the shading can help to define the object in terms of shape and identity, the shadows will create a sense of placement on whatever surface your subject is positioned. As a rule, the shadow cast onto the surface will be most effective if it is a little darker than the subject: this helps visually to push the subject upwards, in this way giving it more interest.

Next, the cheeses are blocked in with coloured pencils, choosing a different pencil for each cheese. Although subtle, the differences in colour can be identified.

Coloured shading

The three lumps of cheese are placed so that the shadows cast by them help to connect the group together visually. The shapes are then drawn individually with a B pencil.

much darker tone

A light application of violet to the yellow of the cheese has not drastically altered the colour, but a change in tone can clearly be seen

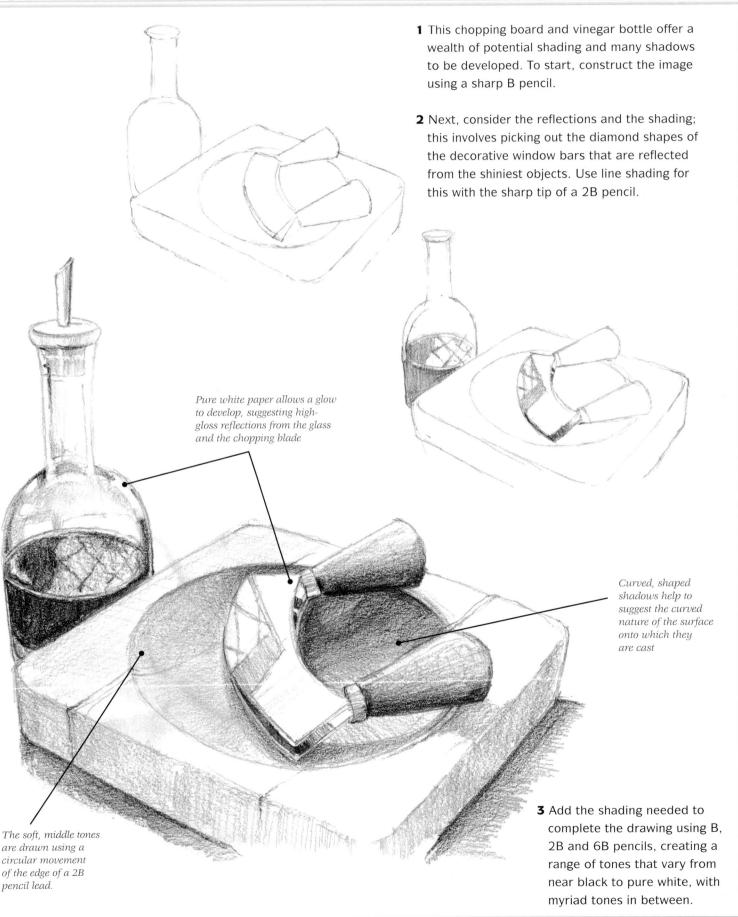

Patterns

Many fabrics, and objects made from them, contain patterns that make them extremely appealing to draw. They can, however, be a little intimidating because of the complexity of the patterns once the fabric is folded or creased.

One of the most valuable exercises you can do to help train your eye to follow the shapes of patterns is to practise following lines and shapes with your eye and drawing these without looking at the paper. This may seem difficult at first, but you will soon be able to transfer information from your eye to your hand without looking away from your subject.

The next stage was to develop the bulk of the colour. I used watersoluble colour pencils to give a more fluid look to the folds, and at this stage concentrated on the light and dark tones, leaving the stripes for later.

The darkest shading is

reinforced with pencil

applied, to create a deeper tone

after the wash has been

eye to lead your hand as you follow the line of a pattern in a subject like a college scarf. I started this drawing by creating the shapes as a series of lines.

> The last stage was to draw in the distinctive red stripe and then to wash across the colour with a wet brush. This dilution of the watersoluble pencils created the middle tones that completed the picture.

A few flashes of white paper left untouched by pencil or brush help to define the tops of the folds in the cloth

1 The shape of the cap is critical to this composition, so draw it first, and only then begin to add the detail to be found on the T-shirt.

gentle feel to the shirt

2 Next, draw in the shading on top of the white shirt using a soft violet coloured pencil, looking closely into the dips and folds that are created by the crumpled fabric.

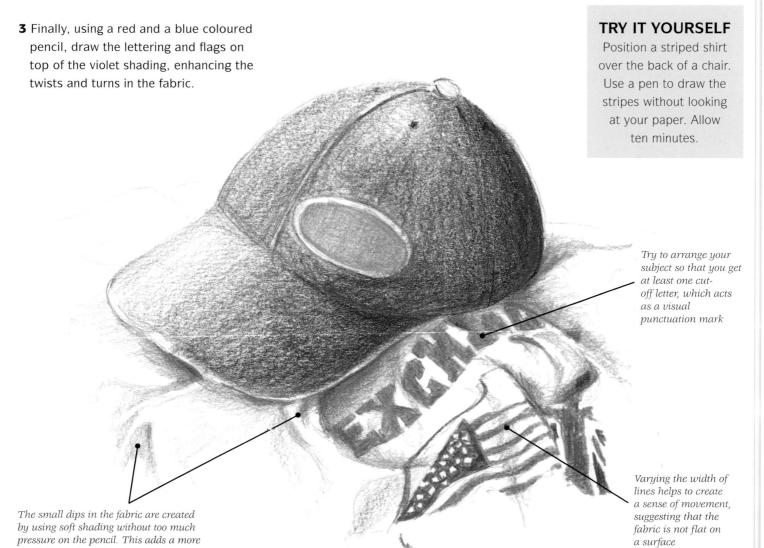

Foregrounds

Having examined the way in which you can draw groups of objects together, it is now time to give some attention to drawing the surface on which your subject is placed. Patterns can help to lead the eye towards the subject of the drawing.

You may like to start off with some basic patterns, such as simple stripes or the classic gingham-checked cloth that artists have traditionally employed for over a century. Alternatively, wooden surfaces such as pine offer some good patterns, although you should make sure not to choose anything so complicated that it will detract from the subject.

Placing the object towards the back of a piece of fabric means that you will have more to draw in between you and the object – that is, the foreground; don't forget the tabletop perspective.

Adding a foreground

A single object on its own always has a sense of isolation attached – it is only when you introduce a foreground that it develops a sense of belonging to any one particular place.

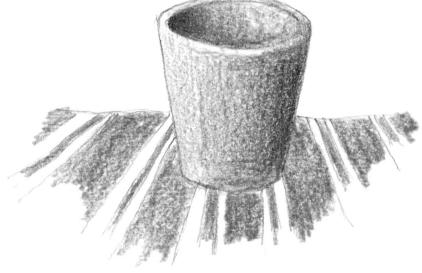

As soon as you add a shadow to visually anchor the pot to the surface you have completed the middle ground, allowing the foreground to take care of itself as there is nothing more to be added to the composition.

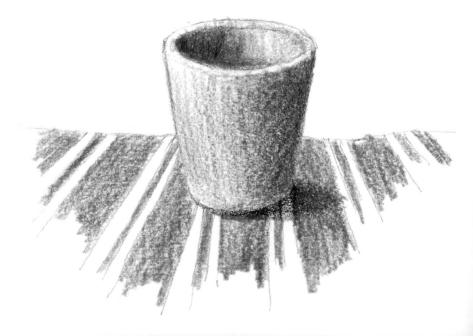

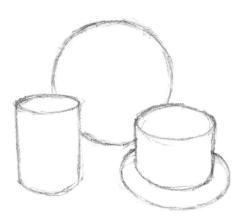

1 To start a drawing of a teapot, milk jug and cup and saucer, create a series of cylindrical shapes without a background or foreground at this stage.

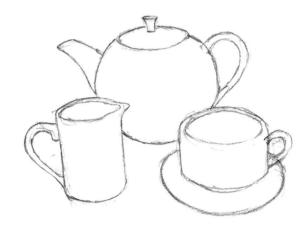

2 Next, draw the details, such as the handle, spouts and lips, to complete all the information required for the group itself.

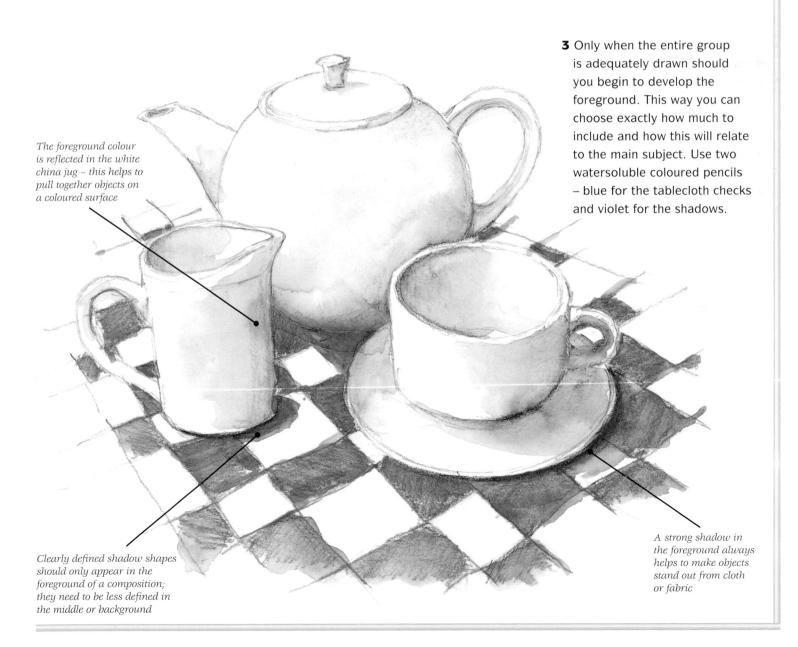

PROJECT: Linen suit

Maybe you had not considered going to your wardrobe in search of a suitable subject to draw, but you will be surprised at the choices you can find. I chose a soft fabric suit because of the number of folds and creases that appear when it is hung up.

To recreate the softness, use watersoluble graphite pencil: as soon as this is washed across with clear water, a whole new range of middle grey tones is instantly created more, in fact, than you probably saw when you drew the dry tones.

1 To give a very light touch in the first stages of drawing, hold your pencil lightly, so that it almost wobbles in your hand and gives your lines a much softer feel. This is particularly well suited to drawing soft fabrics.

Always leave a few flashes

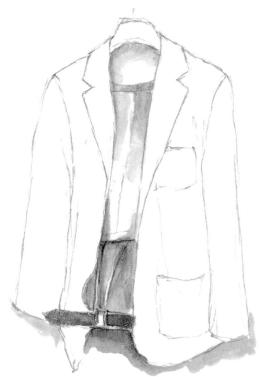

2 Next, using a watersoluble graphite pencil, begin to develop the trousers that are hung inside the jacket. Working from the inside out means that you can judge just how dark or light the jacket needs to be once the shadows it casts are established.

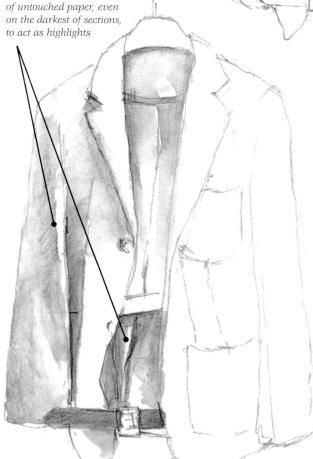

3 You can now begin to draw the shaded sections on the sleeves of the jacket. Develop the middle tones first, because it is easy to lose control of the study if you go too dark too quickly.

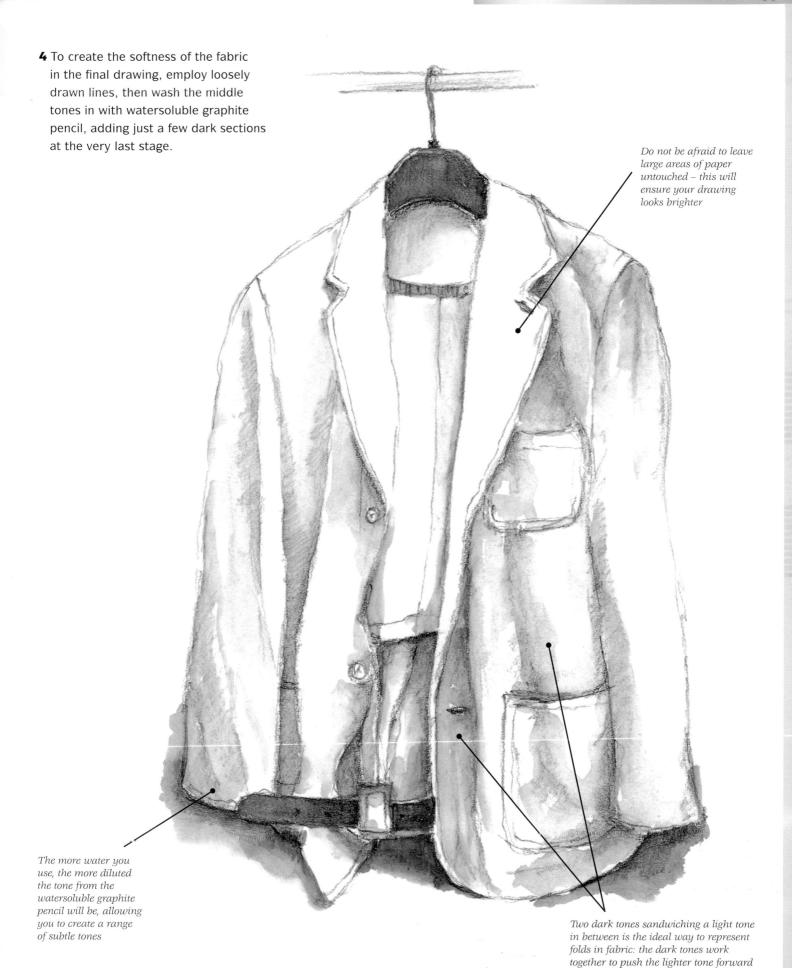

Organic forms

Organic objects, vegetables in particular, always provide the artist with excellent subjects to draw. They are often round or conical, and usually contain some linear detail.

Vegetables and fruit are easily accessible and can be arranged to suit your particular requirements – a simple study of one onion or a more adventurous drawing of the contents of a shopping basket, for example.

If you choose to draw vegetables with leaves, you also have the opportunity to explore the depths of shading and the intricacies of positive and negative shapes.

Onions

The first stage of drawing this simple pair of onions was to create two circular shapes around which the drawing would develop. The lines of the skin were then drawn around the circular shapes, picking out the loose skin at the top.

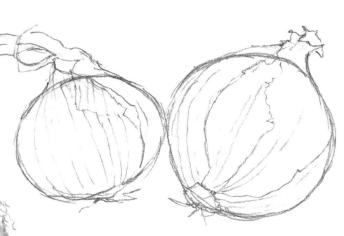

I used watersoluble coloured pencils to block in the onions, creating a sense of form by including a few highlights and increasing the tone for the darker shaded sides. This was then washed over to create the soft, fluid effect of watercolour.

TRY IT YOURSELF

Find two leaves from the same plant or tree. Place them together, with one upside down. Draw one leaf with the veins as positive shapes, the other as negative shapes. Allow 20 minutes.

To complete the drawing I added a few details. Once the wash had fully dried, I used the same watersoluble coloured pencils, sharpened to give a more clearly defined line to draw in a few of the onion skin shapes.

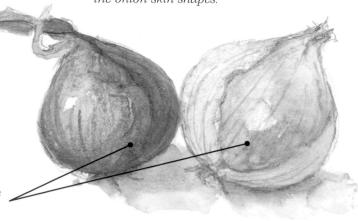

Note how the lines curve around the sphere of the onion, helping to define the shape

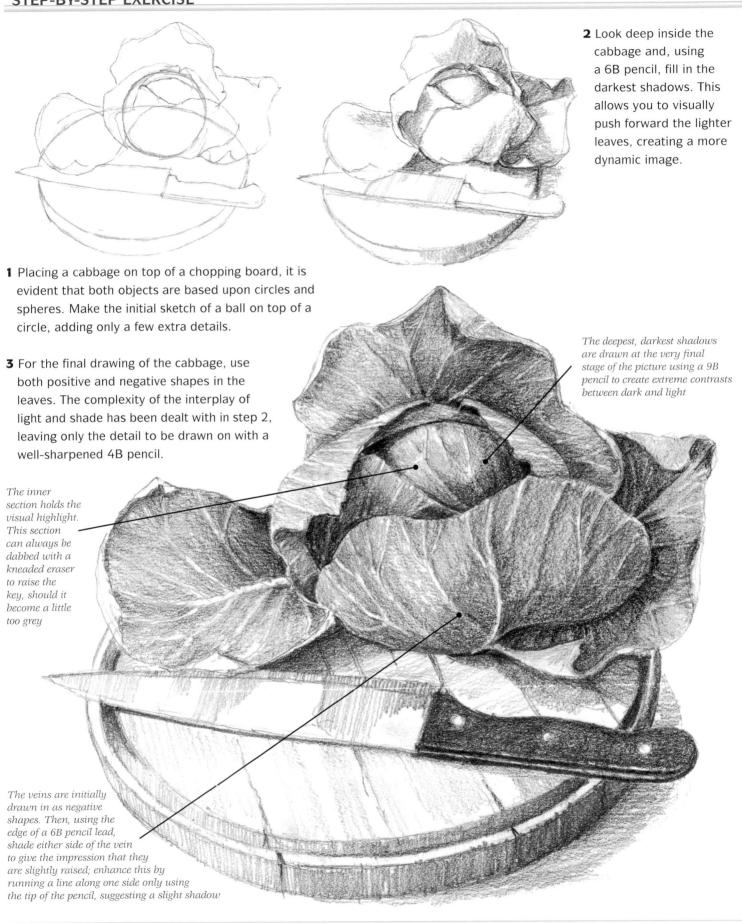

Texture

To learn to create a sense of texture within your drawings, you need to start to rethink the way in which you apply pencil to paper. Much texture can be created by adopting a 'rougher' style of mark-making, including crosshatching, often requiring the use of a series of rapid stabbing or stippling pencil marks.

These techniques can also be used with watersoluble pencils, both coloured and graphite. A wet brush can also be used to 'rough up' a drawing, creating an uneven look through an uneven application of water; scrubbing and using quick, jerky brushstrokes helps to create a textured surface to draw on.

Pastry texture

The texture of this crusty Cornish pasty was created by drawing with a series of short, sharp stabbing marks made with the edge of the lead of an 8B pencil. This helps to recreate the flaky and pitted textures seen on this type of subject.

Texture in colour

The simple shape of this croissant was drawn using a B pencil. I then developed it further by drawing with raw sienna watersoluble coloured pencil, adding burnt sienna for the darker sections.

Finally, the same two coloured pencils were used to work on top of the now-dry wash, this time using the tips of the leads to create some crosshatched effects and enhance the sense of texture.

Next, a damp brush was used to activate the colour by making sharp, jagged brushmarks, unlike the usual 'flow' of colour that occurs with a smooth wash. This helped to add a sense of texture.

- 1 Make the initial drawing of this composition of a wicker basket full of bread rolls with a watersoluble graphite pencil, ensuring that all the curved objects fit within the circular basket.
- 2 Next, use the same pencil to establish the main blocks of shadows and shading, giving a sense of form to the group.

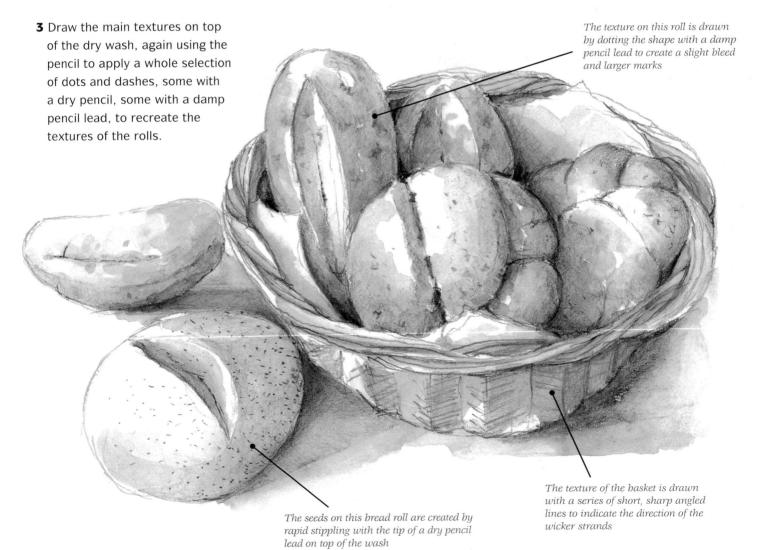

Colour

As artists we inhabit a world defined by shape and colour – we see things in a way that others do not. Spotting good colour combinations will soon become second nature as you begin to look around you, constantly seeking subjects for drawing.

The objects that jump out most vividly are those that are opposite each other on a colour wheel – red/green, blue/orange, yellow/violet. These colours react to each other in a dynamic way and are often referred to as complementary colours.

Some colours share the same base – lemons and limes, for example, both have yellow as a base colour. This will create a softer, more harmonious effect, but you can add a purple shadow to make the composition jump into life.

Red and green complementary

These two peppers, one red and one green, placed next to each other create a dramatic image. This is because they are complementary colours and will always create

a strong visual dynamic when placed in close proximity to each other.

Yellow and purple complementary

This study of a collection of lemons and limes was made with watersoluble coloured pencils. Once again, I used the complementary colour for yellow - purple - to give the drawing more impact.

The darker tones on both peppers were created by the addition of a blue coloured pencil to deepen the colour even more

1 First, wash the basic sap green colour of the leaves on top of a pencil line drawing, using a very watery watercolour mixture. Allow this wash to dry.

2 Leaving the grapes as negative shapes, add some ultramarine blue to the previous paint mixture, darkening the green considerably for the darkest tones. Apply this to the shaded area and underneath where the leaves fold over, to create a sense of light and shade. 3 Use the same purple tone on all the grapes, ensuring that

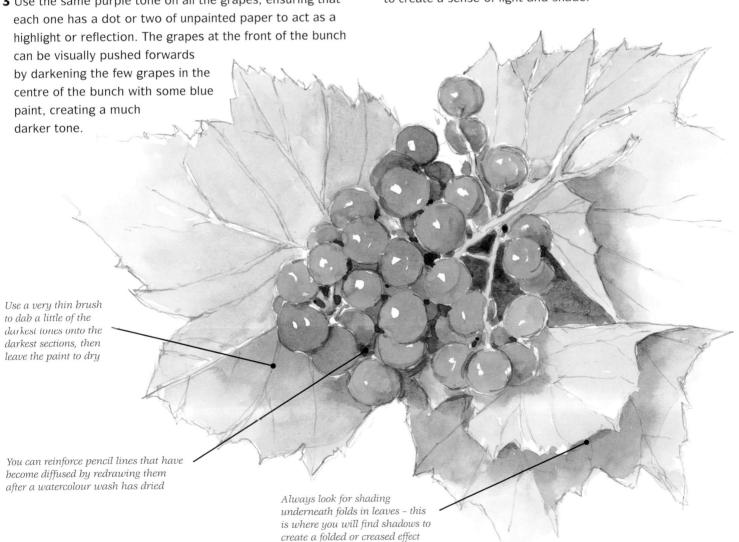

Compilation

Meal times may not always be considered the best time to start a drawing, but the preparation of cold foods can afford the artist a wonderful opportunity: salads can be highly coloured, for example, with complementary reds and greens visually jumping off the plate and coloured meats containing a wealth of patterns.

You may find it helpful to start off by making a few studies of objects that catch your eye: a cut tomato or a lettuce leaf, for example, will force you to make some judgements about the particular medium or media best suited to drawing it. While the very nature of these objects means they will usually scream out for colour, some subtle tonal work may well be appropriate.

The three-dimensional appearance was created by ensuring that highlights remained uncoloured to indicate light bouncing from the shiny surface

Tomatoes

Glowing with vibrant red, tomatoes are always irresistible for drawing, especially with coloured pencils. Apart from the green stalks, this drawing was created with two pencils only - orange to create the vibrant undertone, and deep red to create the strength of colour.

> The pips were created as a series of tiny negative shapes, with only a hint of shading to prevent them from glowing like the highlights

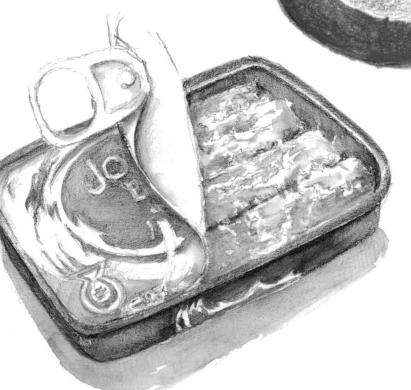

Sardines

A half-opened tin of sardines may not sound like an ideal subject for a picture - but look at the textures, twists and turns in the open tin and the detail on the lid. Watersoluble graphite pencil seemed ideal for creating the variety of tones and textures found in this simple subject.

1 Draw the shapes of the food on a plate using a series of near-circular shapes. If you view these as transparent shapes, you can visualize how they overlap and how they sit together on the plate.

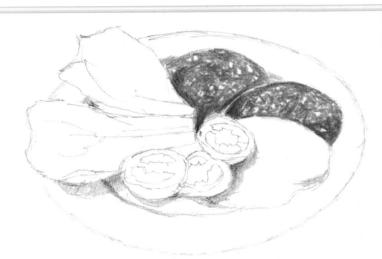

2 The cold meat forms the bulk of the composition, so draw this first. Use a strong pink coloured pencil both to draw the meat and to create the low key shadows cast by the objects on the plate, creating a sense of visual unity.

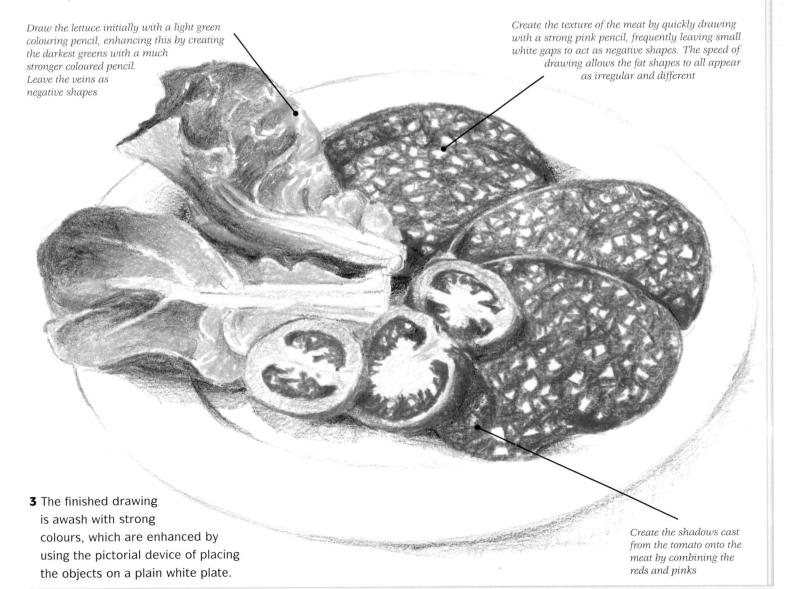

PROJECT: Shopping bag

Some still-life groups are composed of objects that you might never think of putting together - sometimes when you empty the contents of your shopping bag onto the kitchen floor, everything seems to fall into place.

The interplay of

light and shade

is recorded here by darkening

sections that can

be seen next to

emphasizing the

light sections,

contrast

While some arrangement did take place to create a visually appealing set-up, the inspiration came from the simple act of random unpacking, so it's worth always being on the lookout for the unexpected.

I chose coloured pencils for this project to provide the strength of colour to deal with the terracotta tiles and the bright greens of the vegetables, as well as being able to create many subtle tones.

1 The first stage of the development of this drawing is to record the way the spring onions sit at unusual angles, tracing the lines from top to bottom and maintaining their flow.

2 To record the subtle green tones of the leaves, first work along the shapes with a light green pencil, then look for the darker sections and work on top of these with a dark green pencil, blending the tones where necessary and leaving hard lines for the shadows.

> 3 Next, add the colouring of the tiles to push the onion bulbs forward into the foreground, and introduce the colouring of the brown paper bag to allow the light and shade of the leaves to appear even more pronounced.

The darkest sections here are created by drawing with the tip of a dark blue pencil, using more pressure to achieve the very darkest shadows at the bottom of the bag The final composition is a mixture of greens and browns – even the bananas hold a strong green element, while a raw sienna pencil creates the warm tone of the tiles and the paper bag.

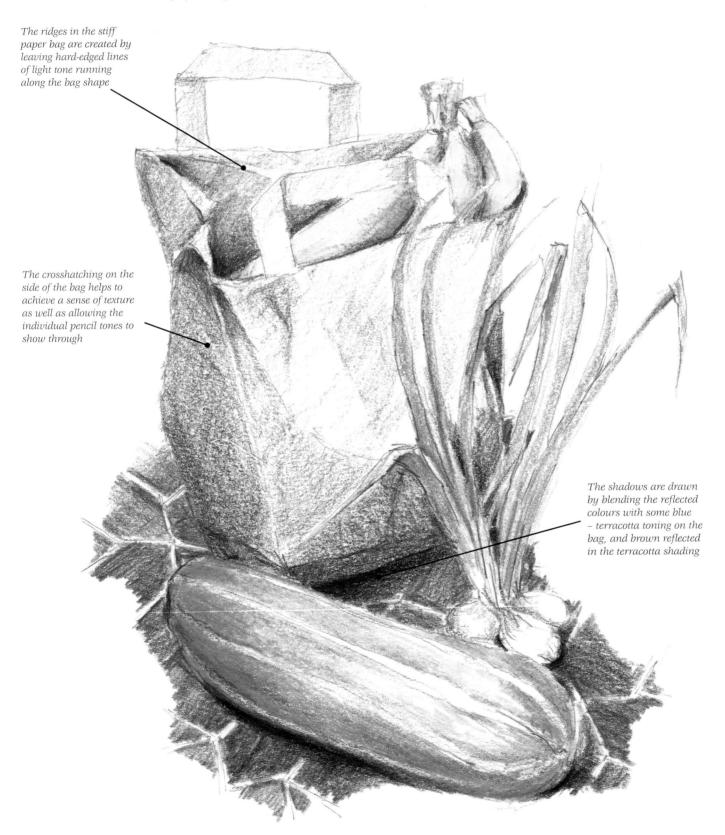

Windows

Whatever the weather, you can always introduce a little of the day outside into a drawing by looking through a window or door. Doors and windows present you with a readymade composition: just treat the door or window as the frame for your picture, and all you need to do is look through it to focus on your subject.

Opening doors and windows introduces a new element altogether, as angles and perspective enter onto the scene – these can enhance your pictures as they break the static picture plane by thrusting a sharp diagonal line across a potentially flat image.

Open window

This quick sketch was made to capture the fleeting effect of the wind blowing through an open window on a fresh spring day. Curtains can obscure part of the frame and may even move while you are drawing; I used a watersoluble graphite pencil to soften the lines of the flowing fabric and to suggest the billowing clouds outside.

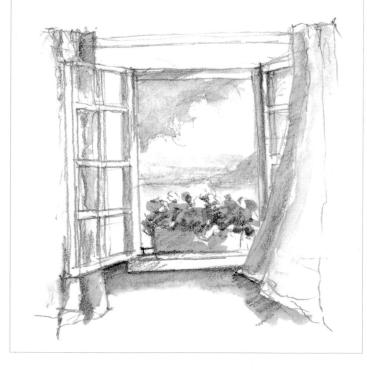

Window box

Window boxes can start off as simple cubic shapes, using tabletop perspective to ensure that the lines of the top converge slightly.

Next, mark two points along the bottom line and take lines to the upper corners to create angles.

Adding colour

Coloured pencils can be used to make very quick sketches that provide you with information. This sketch was made to record the colours of the flowers and the way in which they complemented the terracotta colour of the pot.

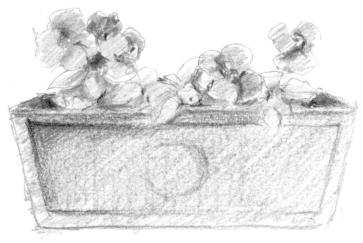

77

STEP-BY-STEP EXERCISE

1 With a window set deep into a thick wall, to ensure that the depth of the walls becomes clear, take up a position slightly off-centre, allowing one side of the recess to be clearly seen. Draw one box shape inside the other.

2 Next, add the structure of the window frame and the vase of flowers. It is important at this stage to draw through foreground shapes to make sure that lines drawn to suggest broken surfaces meet each other on either side of the object.

3 Add watercolour to give some visual lift to the drawing, using violet to create the soft shading on the window ledge. Keep the toning on the wood to a low key, to prevent the paint from taking over the picture.

TRY IT YOURSELF

Place a plant pot in front of a window and draw it framed within the window frame. Allow 15 minutes.

The background outside is suggested by a very soft green The wood grain is created wash - any more information by a combination of darker would compete for attention paint, directional lines and with the foreground a few highlights

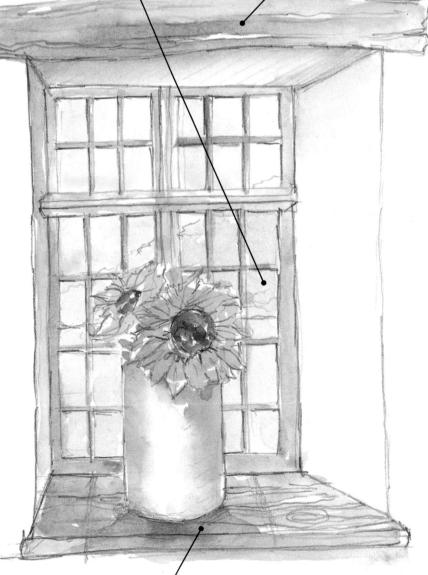

Soft violet shadows indicate soft, muted lighting while adding a feeling of warmth to the drawing

Doorways

Doors offer a world of opportunity to artists: they can be partially opened, fully opened or anywhere in between, and provide the opportunity to draw small domestic snapshots of our own homes.

You need to spend a little time practising your perspective drawing here – just remember that the top and the bottom lines of an open door need to converge to an invisible point in the distance where they would eventually meet. Just how much they converge depends on how wide open the door is.

Door panels

The panels of an interior door should be drawn with converging lines to create a sense of perspective. Always draw a horizontal line parallel to your eye line, and ensure that lines above it converge downwards, and lines below converge upwards.

Door angles

Slightly open doors offer a tempting hint of what may be found inside the room. Doors that come out of the frame towards you will have the top and bottom lines converging

towards the hinged side of the door frame.

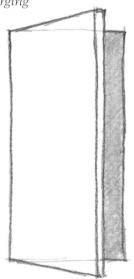

Doors that open into the room allow you a better view of the floor and ceiling. The top and bottom lines of these doors always converge away from the hinged side of the frame.

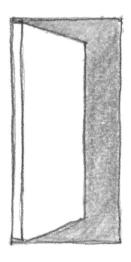

The most revealing doors are those that are wide open, allowing you a full, uninterrupted view of the room. If opened outwards, these doors usually block your view of the frame,

allowing you a compressed view of the door and intense perspective.

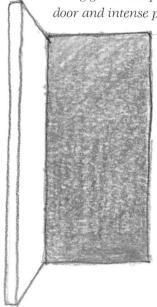

Doors that are fully opened inwards allow you to see even less of the actual door. You may be able to see a gap between the frame and the door along the hinged side.

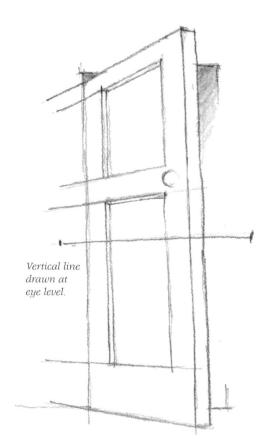

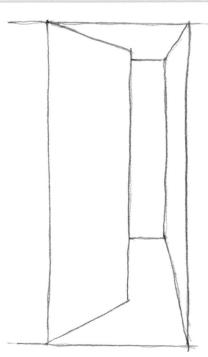

1 First, make a simple line drawing, establishing the angle of the partially open door. Then, looking at the angles of the room seen through the doorframe, construct the two visible walls.

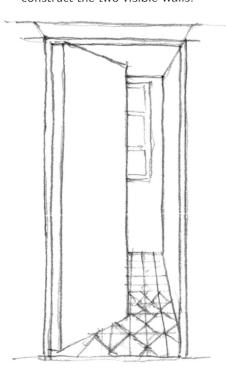

2 Next, develop the perspective, sketching in the lines for the floor tiles, and start to develop the doorframe.

3 Finally, concentrate mainly on the scene observed through the doorframe, presenting the door as a near negative shape. Only a small amount of shading is required to prevent it from looking flat.

Shading in the small recesses of the door panels helps to add a three-dimensional feel

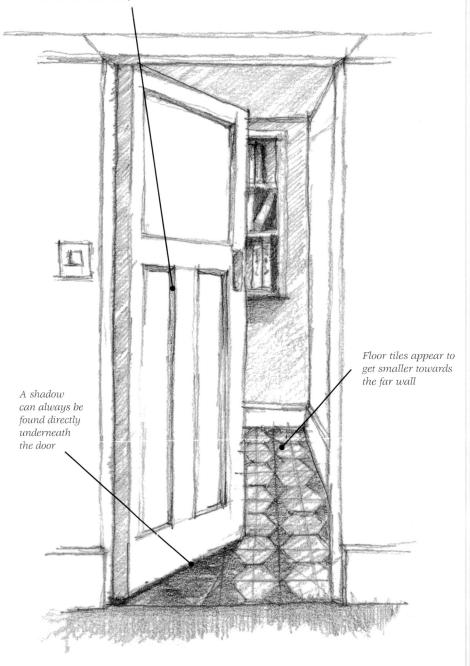

PROJECT: Open French windows

This drawing was the result of a lazy afternoon spent in a holiday hotel room – the French windows were cast open to let the humid air circulate around the room, creating a wonderful drawing opportunity in the process.

I gave serious consideration to the angle of the window frames, which was established at the initial sketching phase with only a few lines – the angle of the windows, rather than any level of detail, was my main priority.

The scene observed through the window was treated to a very light drawing style, as excessive drawing could result in an overworked image.

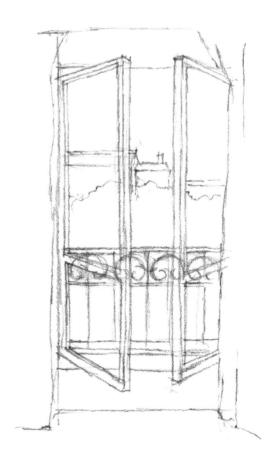

- 1 The first stage of this drawing is to construct the basic framework of the open windows and the window frame. As the windows open inwards, they appear to become larger the closer they are. A simple line drawing is adequate to establish the height, width and angle.
- **2** The next stage is to develop the windows, creating the thickness of the frames. Then begin to introduce the symmetrical design of the decorative railings at this stage, just the bare bones are required.
- **3** To establish the curves and symmetry of the balcony railings, draw across the frame of the door in the knowledge that the lines can be removed with the tip of a kneaded eraser. Don't be concerned with drawing around or in between shapes at this stage.

4 Complete the final picture with watersoluble graphite pencil. This allows a soft grey set of tones to be created in the foliage seen through the windows, and allows some soft shadows to fall inside the room.

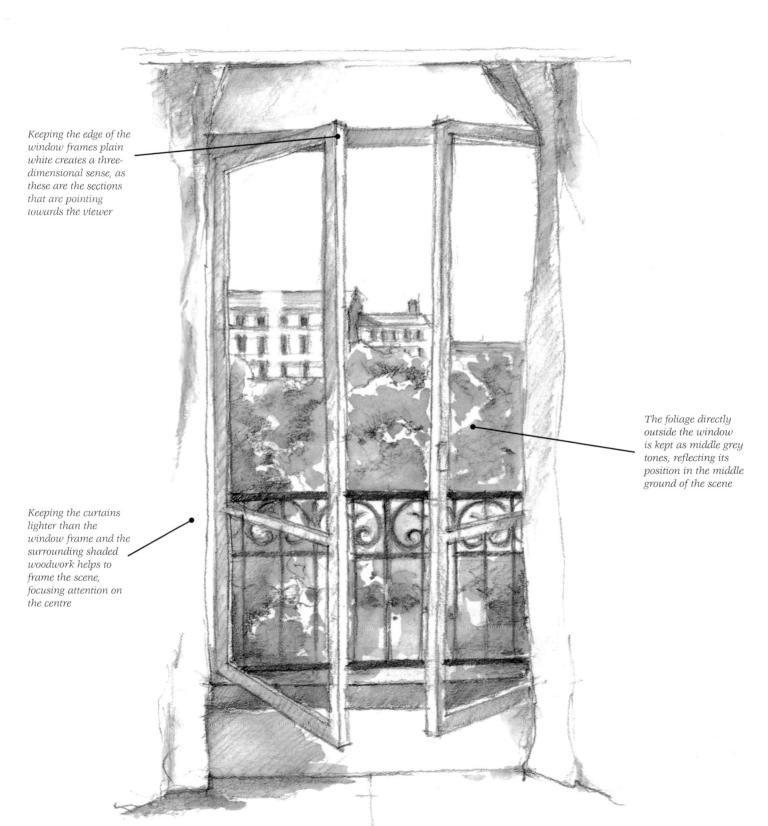

Outdoor drawing: Sunday

Lighting is one of the key differences between indoor and outdoor drawing. Within the safe, secure and warm confines of your own home, you are in total control of the way in which your subject is lit – you can turn lights on or off, or move the subject to achieve the best possible lighting. This is not the case out of doors; the advantages, however, lie in the choice of subjects.

If you start off by looking around in your immediate environment – your own back garden, for example – you will not have to worry too much about packing a bag with all the items you may need, as you can always go back indoors to collect them. Here you are likely to find flowerpots, garden furniture, flowers, vegetables and more, on which to practise your drawing skills.

Sooner or later, you will want to look up, rather than on the ground, for your subjects, and you are likely to be attracted by built structures; and these will, eventually, lead you out of your own garden and onto the streets. Here, you will want to find some comfort as you set up to draw, and you may consider investing in a backpack with an integral seat. This will allow you to carry all of your drawing materials with you in the bag, and you will have somewhere to sit in relative comfort as you begin to draw amongst the wider environment. This is, however, all that you will need, as if you decide to use a ring-bound drawing pad, one with a hard back is well suited to sketching, as you can rest it easily on your lap, removing the need for cumbersome drawing boards, masking tape, clips and other paraphernalia.

Finally, this time you will need to develop your perspective skills to take you beyond the tabletop – but again, do not allow this to become a laborious task. While creating some perspective guidelines will sometimes become a necessity, this should only ever be a small part of the drawing process. The more you practise, the easier it will become for you to see perspective rather than needing to construct it.

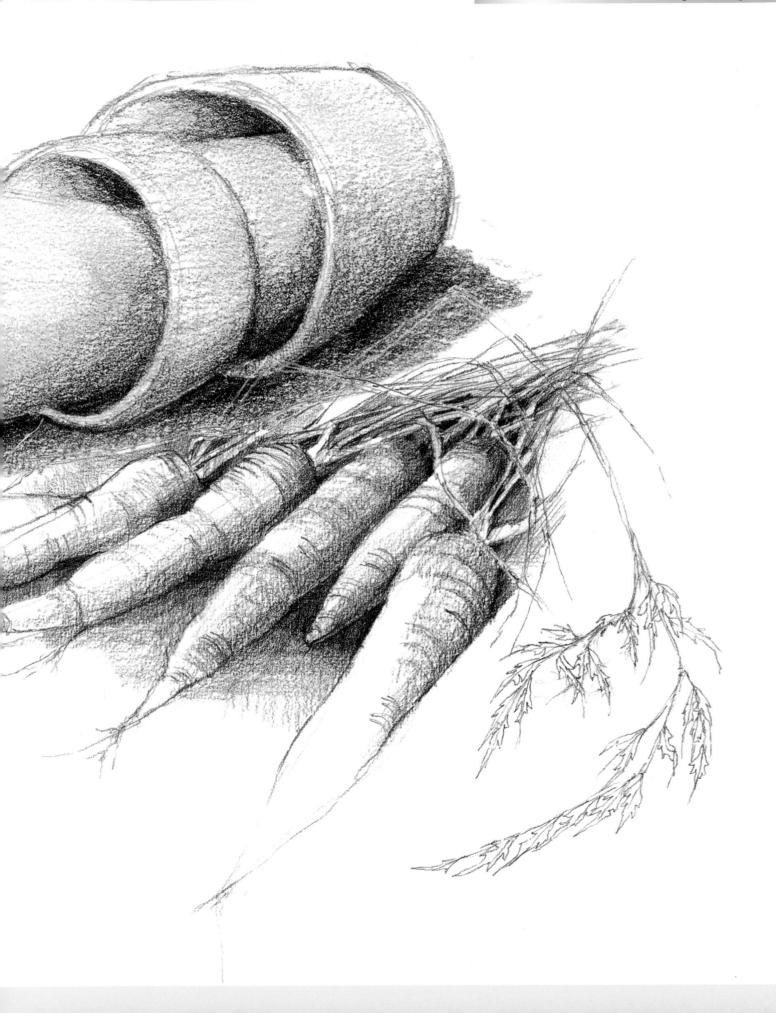

From transparency to colour

Garden pots

Even the simplest of flowerpots can hold a wealth of drawing material for the observant artist – you will find colour, texture, tone and maybe some cracks or splits to enhance your image. And the longer flowerpots have been out of doors, the more interesting they become.

It is a good idea to draw pots as transparent shapes, especially if they are covered with leaves and flowers: even though you may not see the curve of the pot fully, it is still there and needs to form part of your construction.

Pots can easily be drawn with most media, but waterbased materials help to give you much better textures as the water dries and leaves a few watermarks.

Pen and wash

This drawing was made with a fibre-tip pen, and was then washed across in selected places to achieve some subtle tones. Once this had dried it could not be reactivated, so a few light colour washes were added to the leaves and flower heads, as well as to the pot itself.

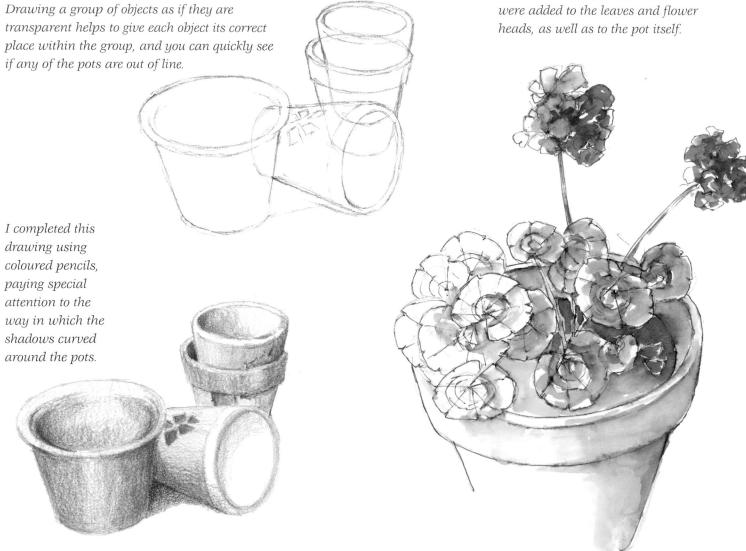

- 1 The first stage of drawing this pot of geraniums is to sketch in the key shapes and then establish the basic colour of the leaves. Draw these with a mid-green watersoluble colour pencil, but leave them dry.
- 2 Next, use a dark green to add a sense of shade and shadow to the leaves, applying the darker tones around the edges of the most prominent leaves, thus forcing them forward into the composition.

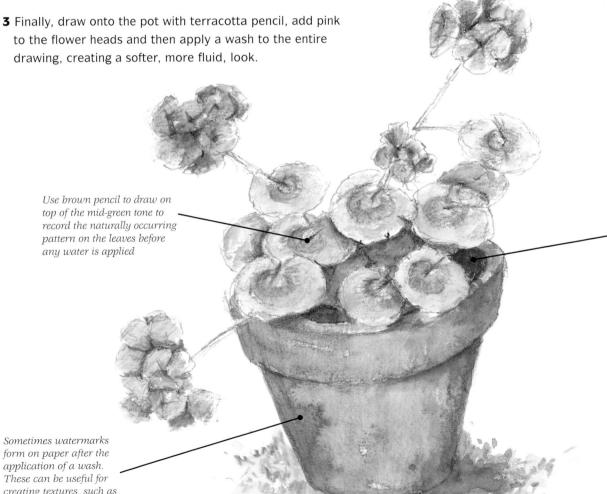

The darkest shadows inside the pot, where little light penetrates, are drawn by adding blue and brown coloured pencils onto the terracotta base

Sometimes watermarks form on paper after the application of a wash. These can be useful for creating textures, such as on terracotta pots

Flowers

The beauty of most flowers is to be found in their colour, so a monochrome drawing may not be the most suitable for this subject (although many flower shapes are well suited to line drawing).

Having selected a small clump of flowers as your subject, start by looking between the stems and leaves to see exactly what is behind them; this is often a jumble of shapes, colours and tones. Do not try to draw these, but aim to suggest them by using colour alone. This will provide something to view the flower shapes against, and will help you to identify the flower heads and leaf shapes more clearly.

Tulips

Having created a line drawing emphasizing the flow of the lines and studying the twists and folds of the leaves, I completely covered everything but the flower heads with a watercolour wash of sap green.

Poppies

The combination of three vibrant colours - red, purple and green - holds the key to this picture. Start off by looking for flashes of colour in a garden, rather than setting out to record large collections of flowers.

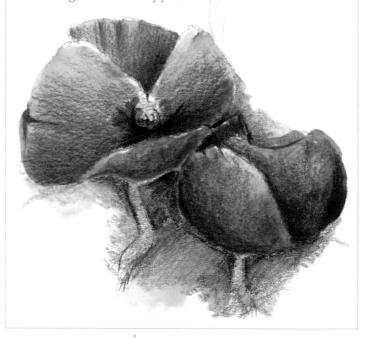

Next, I mixed a darker green by adding ultramarine blue, and painted the shapes behind the leaves and stems. When this had dried, I used primary colours (red and yellow) to paint the flower heads, using a medium brush.

Use a fine brush with a strong paint mixture to draw around the identifiable stems and leaves to create the mass of shapes in the background

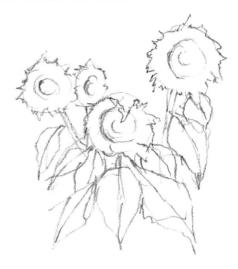

1 A small pencil sketch is the starting point for this drawing. Although you only need to include a little detail at this stage, some information on how the sunflower heads are to be constructed helps, especially where the leaves fall across the heads.

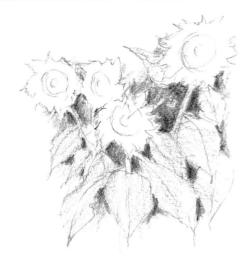

2 Create the background colour next by applying green, blue and brown coloured pencils, but do not blend them fully – this suggests detail without drawing any information.

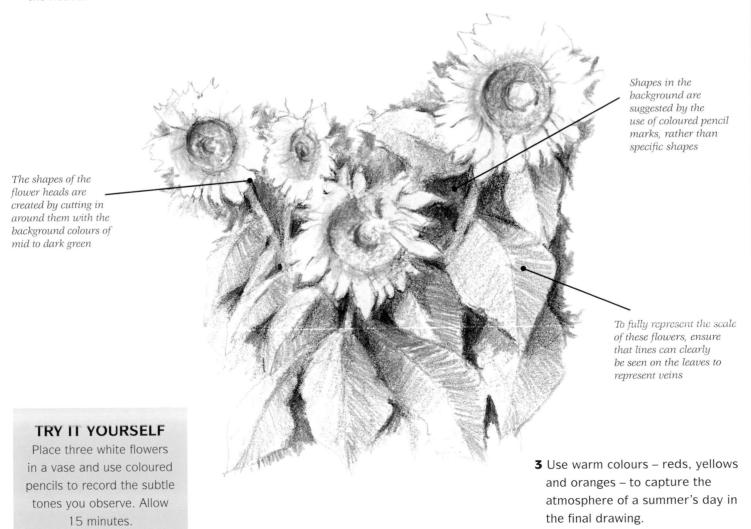

Gardening tools

The garden will always be a good source of subjects for drawing – and the older and rustier dented tools and implements are, the more interesting they become.

A range of textures can often be found that work well together: the roughness of gardening gloves combines well with the surface of terracotta pots, and chipped and damaged trowels, forks and other assorted implements can be mixed and matched to good effect.

But why not start with a single object, such as an old and slightly dented watering can? While the shape may look a little daunting at first, it can easily be created by combining circles, spheres and cones during construction.

Watering can

The main construction stage involved drawing the main can as a cylinder. The handle was created by drawing a ring or double circle.

Next, the long conical shape supporting the rose (which itself is a combination of circular and cylindrical shapes) was drawn in. You may find it helpful to do a little measuring here, checking that the top of the rose is on a level with the top of the handle.

The final drawing was created by shading the circular shapes with a watersoluble graphite pencil, thus creating a graduated range of tones. This was then washed across with a soft, wet paintbrush, pulling the brush in a horizontal direction around the can to reinforce its circular shape.

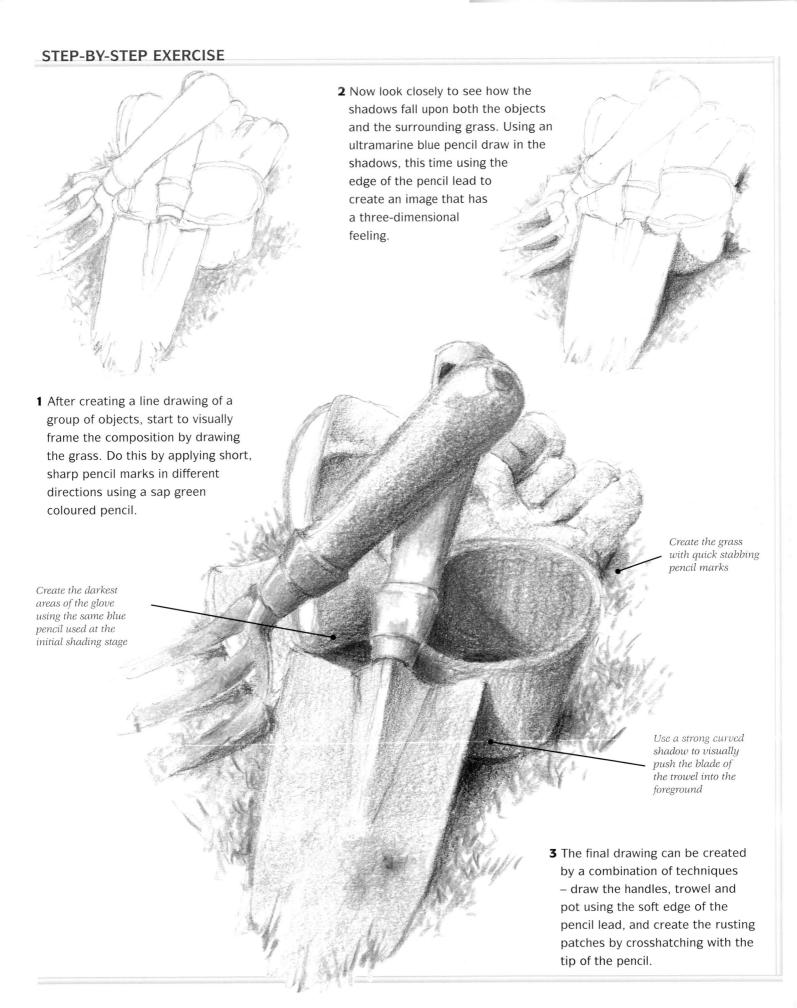

Trees

Ask most people the colour of tree trunks, and the answer will be that they are brown. But we know better - as artists, we look more closely and therefore see more. Of course brown is a useful colour for drawing trees. but it only forms a small part of the overall colour – blues, reds, greens, silver and greys can also be found.

The textures found in tree trunks makes them conducive to being drawn in a variety of media, dry and wet. When using dry pencils, try not to blend colours too much, as only a few pencil lines are needed to suggest bark. When using wet materials, do not be afraid to leave some areas of paper unblended - again, a few lines help to create texture.

Roots

Tree roots can provide fascinating tonal qualities. This study was made with pen and Indian ink - the pen outlines were sketched first, producing a skeletal set of shapes, and the ink was added in two main tones, medium and dark.

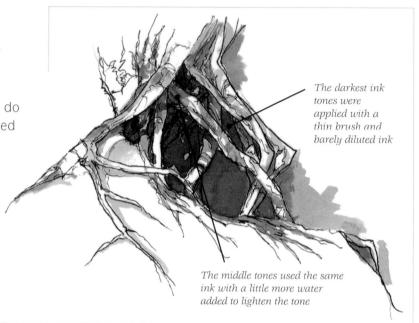

Trunk colours

Coloured pencils are particularly suitable for sketching trees as they are capable of rendering many of the subtle tones to be found in tree barks - especially when used to enhance a strong pencil line drawing.

Monochrome tones

The combination of dark and light in silver birch trees provides good contrast. Watersoluble graphite pencils are ideal for this, as they can be washed across to produce the graduated tone that suggests the curve of the trunk.

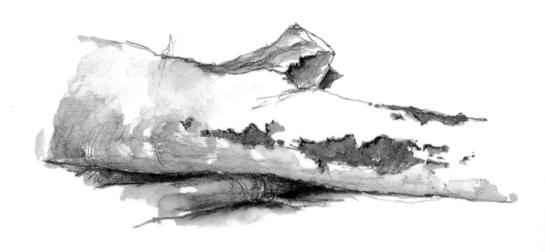

1 Treat the seat built around an old tree trunk as if it were transparent; this allows you to judge the angle adequately, ensuring that it appears to surround the tree, rather than just sitting in front of it.

2 Next, refine the drawing a little: remove the construction lines with a kneaded eraser and draw in the supporting framework, lining up all the main features to ensure solidity.

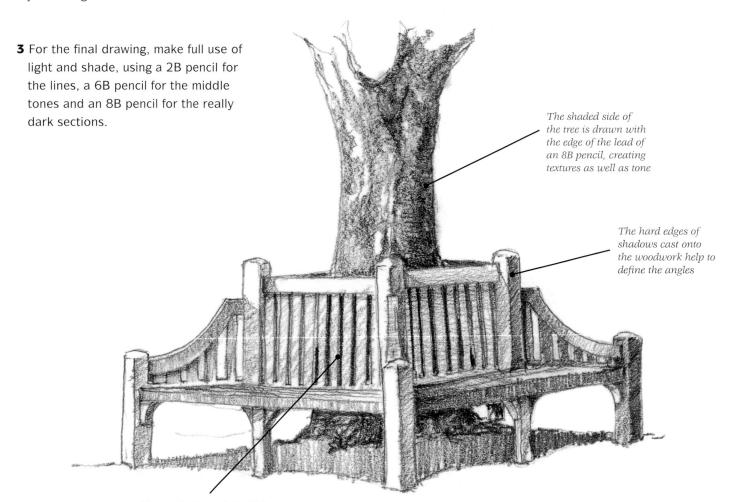

The tree is drawn 'behind' the wooden slats, creating a grid of positive and negative shapes

PROJECT: Spring scene

Sometimes an entire season can be encapsulated in one small area of a garden. Within this clump of spring irises I saw all the key elements of the season – soft, gentle warmth, crisp colours and shadows, and clean, fresh greenery.

It is sometimes difficult to know both where to start and where to complete a drawing of this nature, as clumps of flowers rarely exist within a visual rectangular frame. So ignore the frame and allow your drawing to expand in all directions; this helps to create a much more dynamic drawing as the viewer's eye will be pulled inwards from a variety of angles – not just four corners.

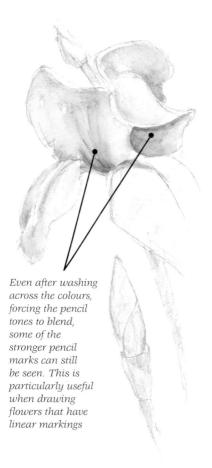

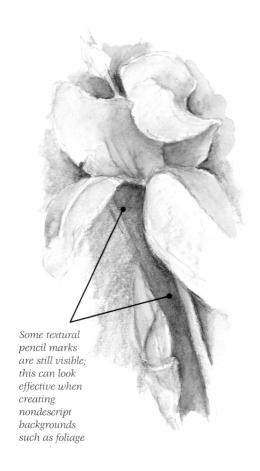

- This project starts with a study of one particular section of the garden scene

 one stem from a clump of irises.

 After making a line drawing of the twisting and curling petals, apply the base colours using soft violet and light green watersoluble coloured pencils.
- 2 Next, introduce the darker tones by using a purple pencil for the slightly darker tones. Draw over the top of these with a dark blue pencil to achieve the darkest tones, and then wash over them with a wet brush.
- **3** To complete the study, darken the area immediately behind the stem with three different pencils one mid-green, one dark green and one blue; these blend together well when washed across.

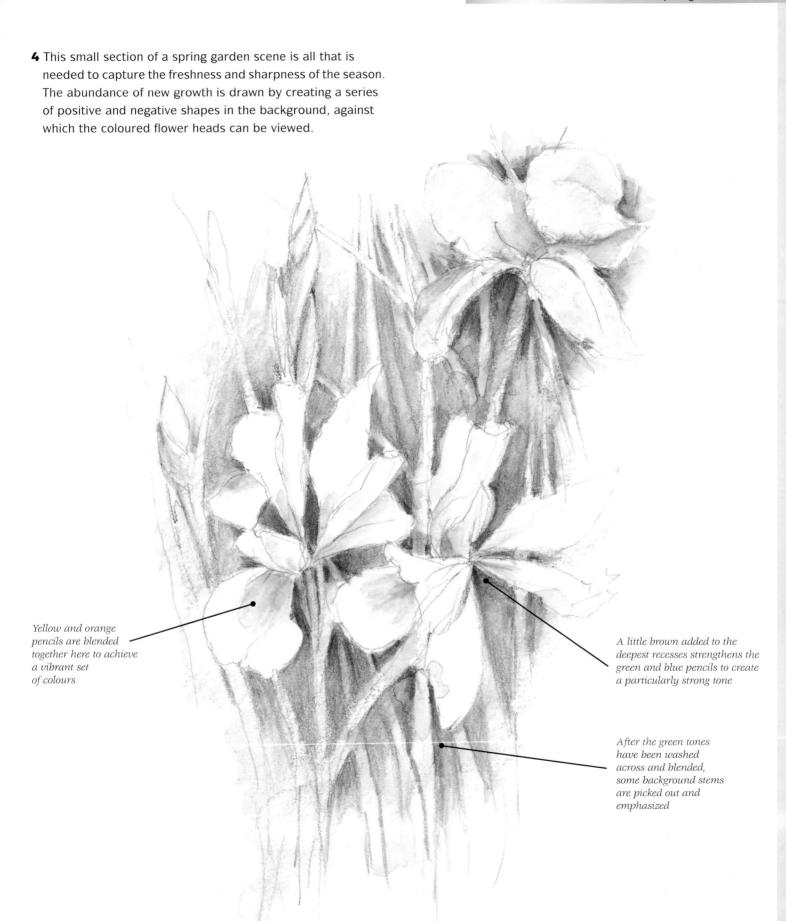

Farmyards

Farmyards contain so much more than animals: you will invariably find a good supply of outdated or broken tools and machines that have simply been left to rot. To some they may seem unsightly, but to artists they are appealing because of their rusty colours and textures.

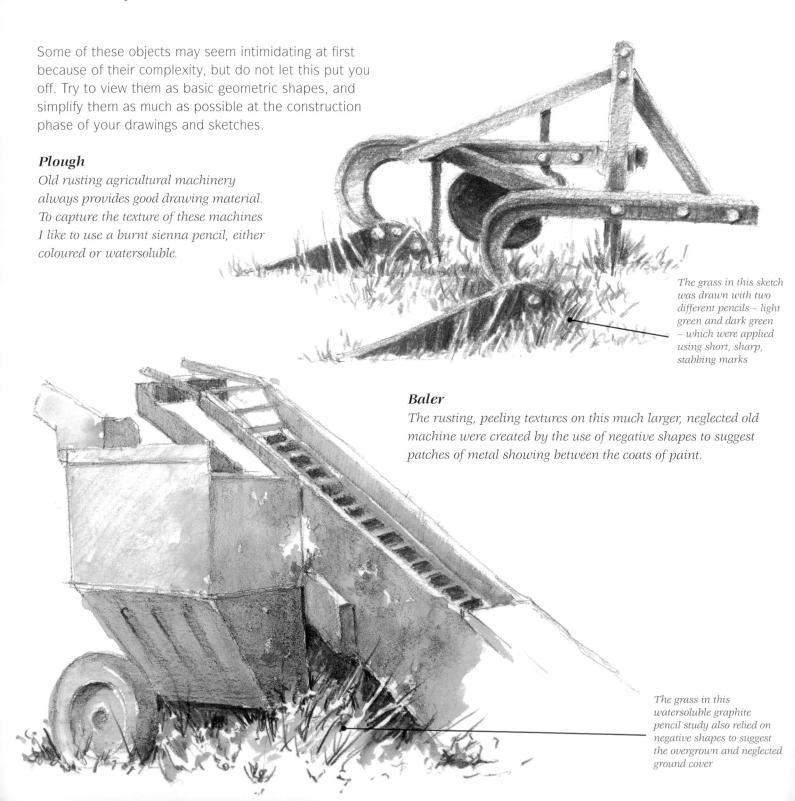

1 For the initial line drawing of this old tractor, concentrate solely on the most basic shapes – the main frame, the wheels and the exhaust pipe. Only when all of these are in place should you begin to develop the drawing.

2 The next stage is to use the edge of the lead of a 6B pencil to rough in the main areas of shadow, forming the basis for the addition of detail at the next stage.

The texture here is

increase the contrast

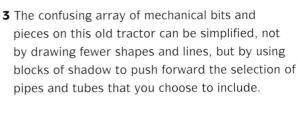

The rough texture of the rubber tyres is created by using the edge of an 8B pencil lead, with little attempt to blend the marks

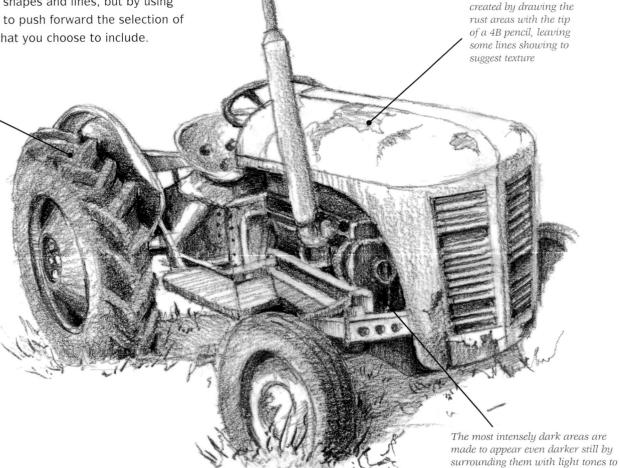

Harbours

The biggest problem in visiting harbours and docksides with a sketchbook is trying to decide which of the wealth of subjects to draw. You will be spoilt for choice with an amazing array of colours, textures and shapes.

You can always find small subjects such as old discarded ropes, broken lobster pots and net weights – the detritus of the fishing industry – and larger objects, such as rusting old anchors, boxes of fish and lifebelts, may well attract your eye for colour studies. But eventually you are bound to be drawn to the boats. Start off with smaller ones (maybe a rowing boat) before moving onto the trawlers and fishing boats that are such attractive features of the harbour side.

Lifebelt

This lifebelt was drawn with two coloured pencils – orange and red. The orange pencil was used to underpin the strength of colour, and the curve was created by drawing the outer and inner edges with the tip of the red pencil.

Glass ball

This was drawn using a watersoluble graphite pencil. As the string netting was not white but a faded yellow, it was drawn as if the string was not there at all; I shaded around the glass bowl with a watersoluble pencil and washed onto it.

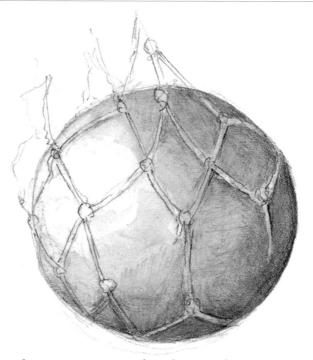

The next stage was to draw between the string netting on the darker side, increasing the pressure on the pencil towards the furthest edge. This in turn was washed across with the tip of a small damp brush, working carefully around the string and making it stand out.

1 When drawing objects such as boats, try to visually strip away all the peripheral clutter that surrounds them and try to see and draw just the most basic of shapes.

2 Next, begin to add a few of the objects that make fishing boats so appealing – rusting iron plates, fender buoys and registration number, as well as the windows in the cabin.

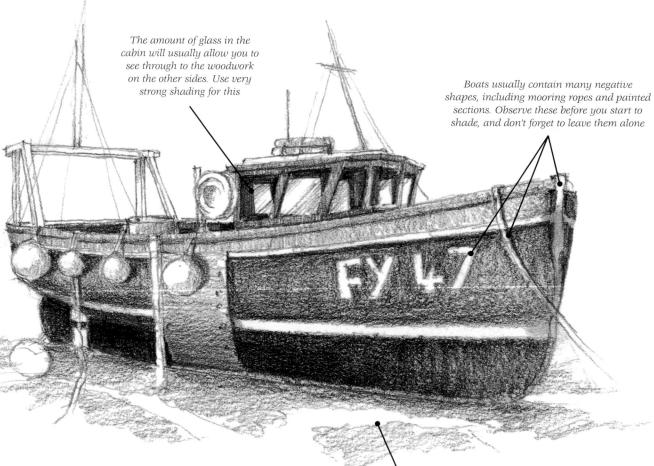

3 Use a 2B pencil for the light and middle tones and a 9B pencil for the darkest tones at the bottom of the boat and the inside of the cabin.

The rivulets of water that usually sit easily in the mud and sand of harbour beds are best left as white paper and shaded around using the edge of the pencil lead

Cafés and bars

Cafés and bars make good subjects for artists – they are usually attractive to look at in an attempt to attract custom, and they often have seats outside, affording you a comfortable vantage point.

Many cafés and bars have courtyards or fronts that have tables and chairs positioned under hanging lights; the interplay of light and shade is important at these delightful places. If there are attractive doors and entrances to entice you in, these will require more information to be drawn into the structure of the building than in the foreground.

Leave a few irregular flashes of white paper in windows to suggest light bouncing from the glass

Café front

This pen line drawing was measured carefully: the top half was equal to the bottom half, with the 'Café.Bar' sign sitting right in the middle. The tree was a useful foil to the stark geometry of this front, breaking up the foreground and adding visual interest.

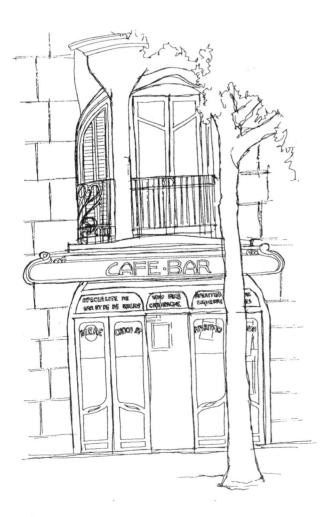

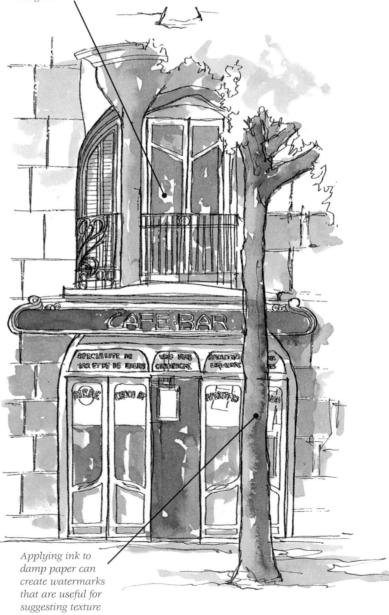

A light ink wash was used to enhance the drawing, building up the tones with each successive application.

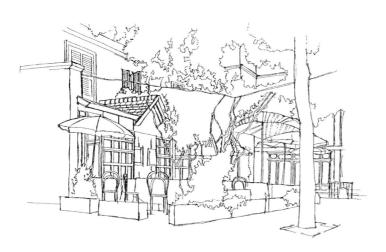

- **1** Take your time making the line drawing of an outdoor café scene, and be prepared to simplify many of the shapes the hanging ivy in particular.
- **2** Next, define the shapes more clearly by adding an ink wash to establish the direction and intensity of the shadows, recreating the dappled effect of the light.

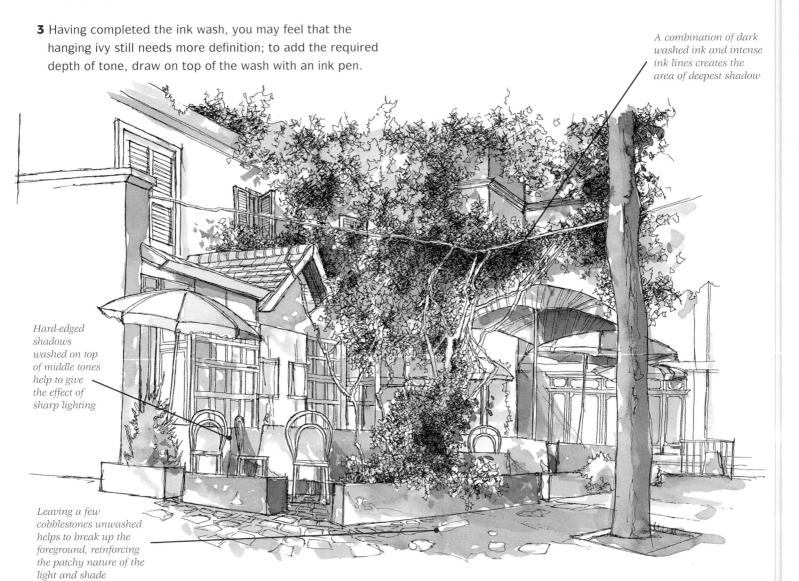

Shop fronts

Even the smallest towns and villages have shop fronts that are bound to grab your interest once you train yourself to look for the interesting bits. Shop windows and doors are usually the most interesting, often displaying badges, stickers and signs that tell you what you might expect to find inside.

Look for the small flashes of simple colour that make the lettering stand out. Drawing these will require you to consider the visual balance of lettering; this may have to be drawn as double lines to allow you to create negative letters by shading behind them. The drawings on this page illustrate how best to achieve this.

Les Routiers

First establish the absolute basic shape and structure of a small shop window sign - in this case a circle cut through by one diagonal line. The lettering sits easily into two blocks, which are sketched in to act as guidelines in preparation for the next stage.

Now use the block outlines to ensure that all the letters are the same size and fit well into the overall design of the sign. Try to ensure that all letters are the same width, and only rub out the guidelines when you are happy with the structure of the lettering.

Now the outline drawing can be turned into a fullcolour piece by working around the shapes of the letters. The simple primary colours so often used by graphic designers add to the impact of this study.

1 The first stage when drawing any shop front is to establish the proportions of the doors, windows and other structural features. Here the shop door window is the main focus of attention, as all the detail is to be found within it. It is a long, thin window supported by a base with two panels and no doorstep – this is all important information.

2 Next, block in the main shapes of the signs and lettering and begin to add detail to the door itself. Once you have the basic visual structure in place, start to add the colours that you observe to create an undercoat on top of which to work.

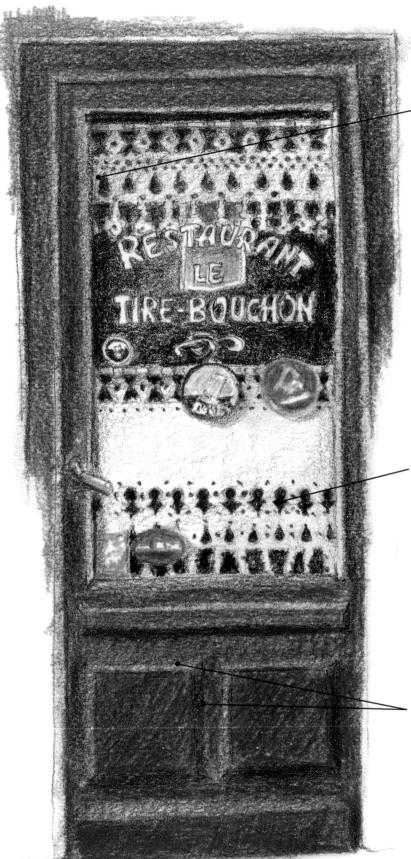

The shadow from the door frame is created by drawing over part of the lace curtain with a soft grey coloured pencil

The detail in the lace curtains is created by drawing around the lace with the tip of a sharpened dark brown pencil

Observation of the lighting on the wooden panel is important, with light on the top and darker on the edges and the bottom suggesting a threedimensional image

3 The finished study relies heavily on the creation of negative shapes within the shop window for both the lettering and the lace curtains. Some strong shading on the outside and inside of the shop also helps to create a strong image.

PROJECT: Market

Markets are usually wonderfully busy places, full of people, colour and noise. But how do you even begin to start to draw in such an environment? The simple answer is to find somewhere to sit and focus on the small section of the market immediately in front of you.

While coloured media would seem an obvious choice for such a subject, I chose to draw this picture in pencil because I soon became fascinated by the way in which the shadows, not the shapes, defined the scene. From the dark shadows underneath the sun shade to the ground shadow cast by the stand, it became clear that it had to be a pencil drawing – and the stronger the better.

2 Once the outline drawing is established, the tones need to be introduced. For this, use the edge of the lead of a 4B pencil and roughly sketch in the main blocks of shadow, noting the sharp angles and the way they fall across the two figures.

1 Sometimes the angles of shades and covers found on markets and fairs may appear unlikely, especially once you have drawn them, but this can be part of their appeal. Irregularity is often more interesting than symmetry.

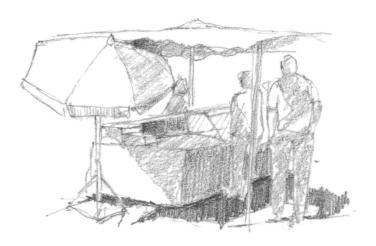

3 To visually anchor the stall and figures to the ground, add the shadows next. These should be strong, sharp and angular; use the tip of a 6B pencil to gain the depth of tone required.

much pressure applied

4 The drawing can be finished by using a combination of techniques – refine some areas of shading on the figures by drawing with the edge of the lead of a 2B pencil to soften the tone, but draw the merchandise using the tip of the same pencil, allowing the lines to show.

The reflections on the glass are created by a few clearly defined, sharp, diagonal lines, made with the sharp tip of a 2B pencil Suggestion is the key to drawing the products for The area directly under sale – trying to include any the market stall apron more visual information is drawn using the tip would make the picture of an 8B pencil with look cluttered

Garden sheds

Garden sheds are invaluable for storing things and, sometimes, as places to escape to. Their variety of textures, simplicity of shape and easy accessibility make them ideal drawing subjects as well.

Most sheds are box-shaped – some more elaborate summer houses and gazebos can be more complex, but you are advised to start with something simple. While I understand the temptation to draw these box shapes with a ruler or straight edge, don't - a slightly wobbly line, or a gap here and there, can only give your drawing a more lively feel, and will prevent unnatural rigidity from creeping into your work.

Multiple sides

Garden buildings can be regular or irregular, and are often unusually shaped. Whatever shape they are, it is not always necessary to complete the shape in your drawing: this sketch was made to record a six-sided shelter, and I had enough information after I had drawn only two-thirds of it.

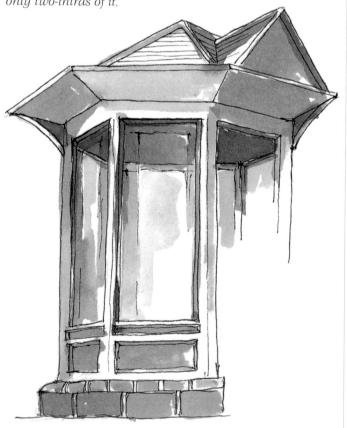

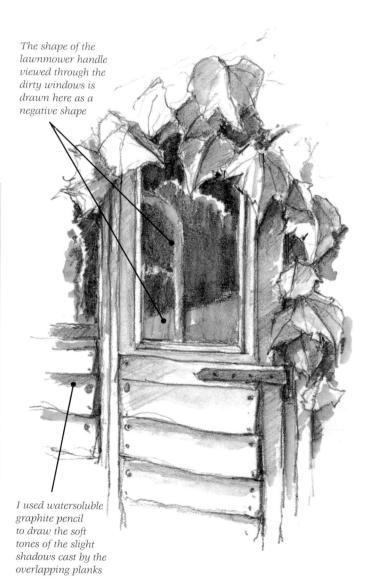

Exploring detail

This close-up study was made for information purposes: I wanted to know exactly how the wooden panels of this garden shed were constructed. Drawing the overlapping wooden planks allowed me to see exactly how the shadows fell and how they were nailed together.

1 The starting point for this drawing of a garden summerhouse is box construction; as with many tabletop objects, even buildings can fit into a box shape – only the scale is considerably greater. Start by drawing a simple box, then add the roof and the lines of the other projected features.

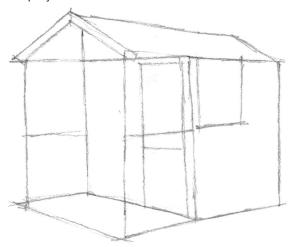

3 Use a watercolour wash to add colour to the drawing – but in a supporting role only: the essence of this drawing is the

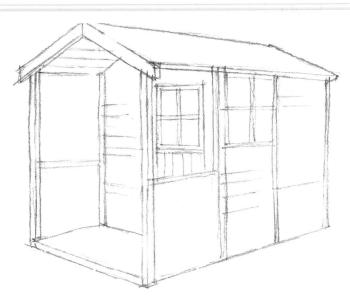

2 The next stage is to add some flesh to the bones, in the form of window shapes, side panels and wooden planks. Be careful to ensure that the lines suggesting the wooden planks converge slightly, in line with the rules of perspective.

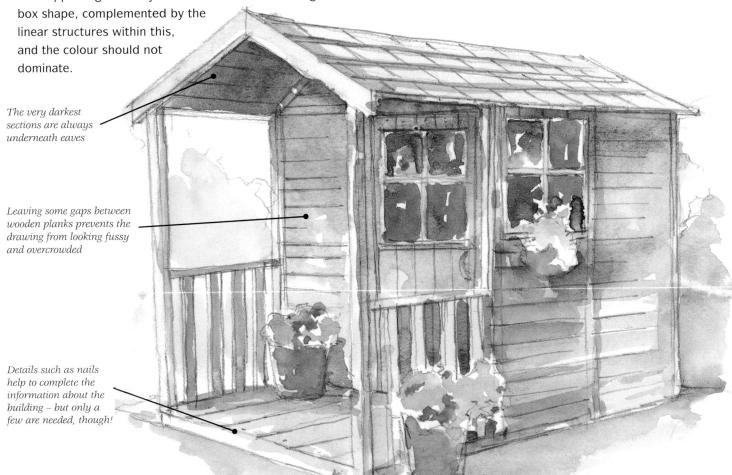

Huts and cabins

Huts and cabins make ideal drawing subjects as they are not as complicated to draw as other buildings, yet they invariably contain human touches that make them interesting, such as a rusty padlock on a seaside beach hut.

Starting with a simple rectangular box, you can easily create the outer structure of a hut, and then complete the outside by adding a triangular roof. After this triumph you can afford to relax and pick out the bits and pieces that make each one different – the paintwork, a window box, waterproof clothing hanging on the door, or whatever grabbed your attention in the first place.

Beach hut

This drawing of a beach hut began its life as a simple, threedimensional rectangular shape with both sides converging.

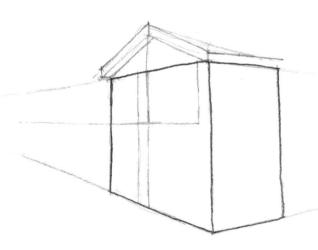

Getting in close

The simple geometry of the padlock combined with its rusty colouring made it a highly appealing subject. Again, only three coloured pencils were used - burnt sienna, yellow ochre and brown - and this time I chose watersoluble pencils to achieve a sense of age and texture.

The rust textures were created by drawing on top of the first wash, allowing lines and shapes to stand out

The doors, windows and roof were added, ensuring that these features all converged within the limits of their respective walls. Only three coloured pencils were used - one light blue, one dark blue and one grey/brown. The wooden planks help to create a sense of convergence within the hut, enhancing the perspective.

1 In the initial line drawing, try to capture some of the visual clutter found around working huts and cabins. The lines of the wooden planks are important to suggest the open door.

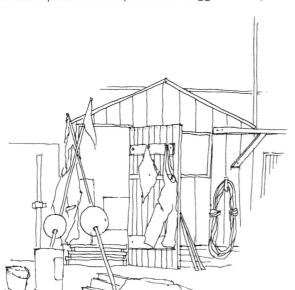

2 Use only one tone to create the ink wash that suggests the shadows. Once these are dry you can enhance them with further washes, but for now use them to help you see exactly where the key shadows fall.

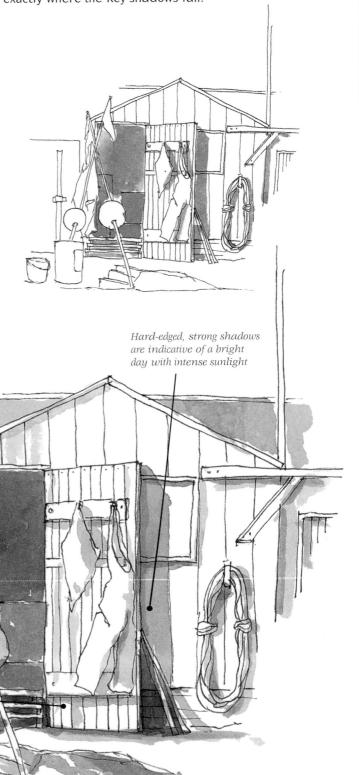

3 Even if the final drawing is full of the clutter in the scene, try to maintain the simplicity of a quick sketch, so the drawing itself is not fussy; suggestion is the key.

The highlight of the fishing float is much more noticeable for being placed in front of the dark cabin interior

The long, straight, vertical planks of wood contrast with the wider, more substantial planks used in the construction of the cabin

Having mastered the structure of small huts, you should be ready to move on to slightly bigger structures. Cottages are basically small and picturesque houses that can be built of any material, so they afford you the opportunity to practise a range of drawing techniques.

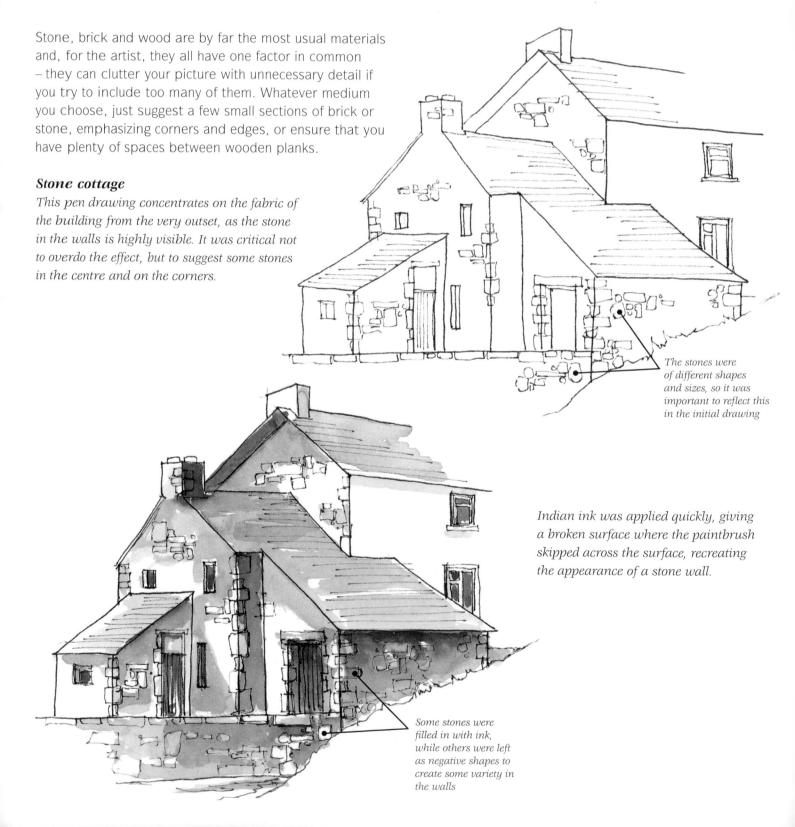

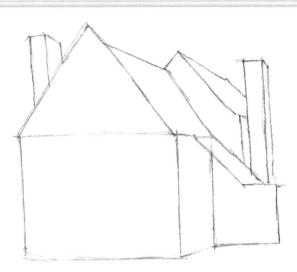

- 1 First, draw the outline of the angular cottage in preparation for a watercolour wash. This means that the lines have to be strong enough to show through the colour, but not so strong as to look unnatural; use a 2B pencil for this.
- 2 Having established the basic box structure, add the key features, such as the bay window and garden walls. You can immediately define these more clearly by painting in the main shadows with a neutral grey/violet tone.

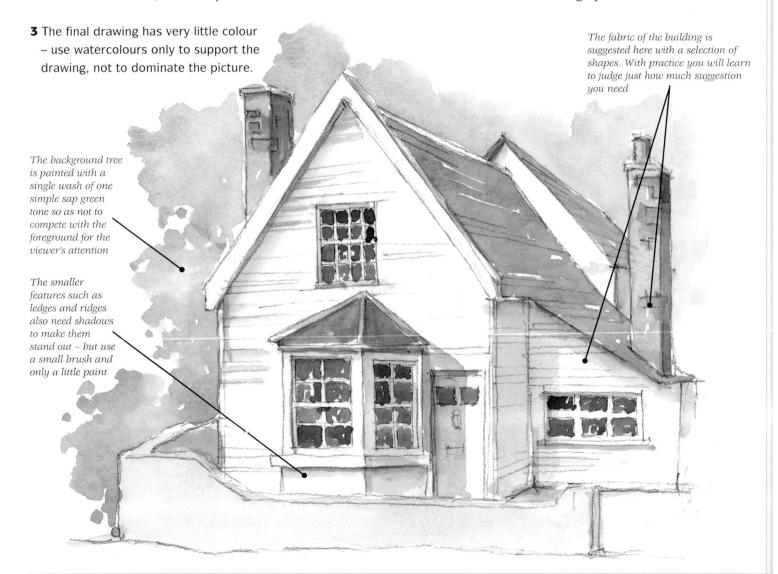

It would have been easy to walk right past this derelict old barn – much of it was enveloped by bindweed and rampant undergrowth. However, the exposed beams at the top caught my attention and encouraged me to take a second look, and only then did I realize its full potential.

Because the drawing was going to be roughly half building and half ground cover, I used watersoluble graphite pencil to enable me to achieve a full range of tones, with a dominant mid-grey range.

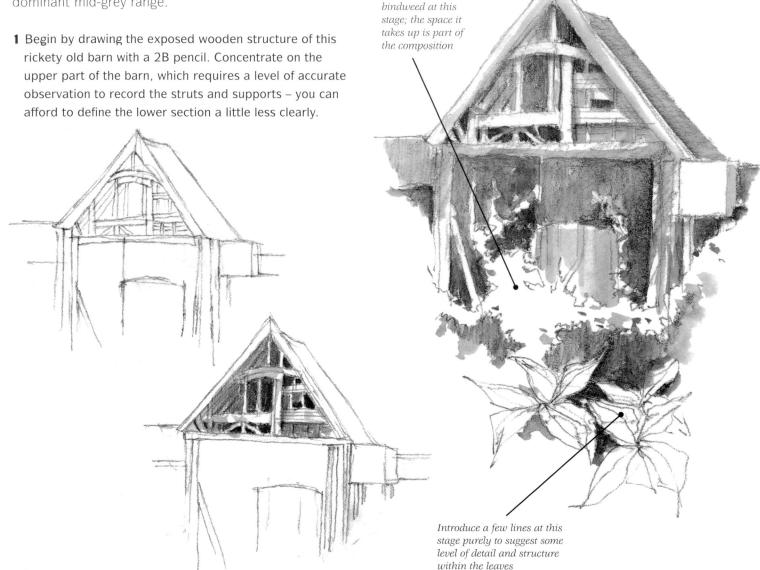

Leave the main

bulk of the

- **2** Using a watersoluble graphite pencil, draw the shadows that thrust the wooden structures of the roof forward, creating an array of negative shapes. Use a wash of water to tone down the pure white of the paper on some sections, but leave others untouched to suggest sun-bleached wood.
- **3** Work down the barn to the growth from many years of neglect the weeds, grasses and groundcover leaves occupy a major section of the composition. Start by sketching these in and work around them, allowing the wooden structure of the barn to maintain its importance in the drawing.

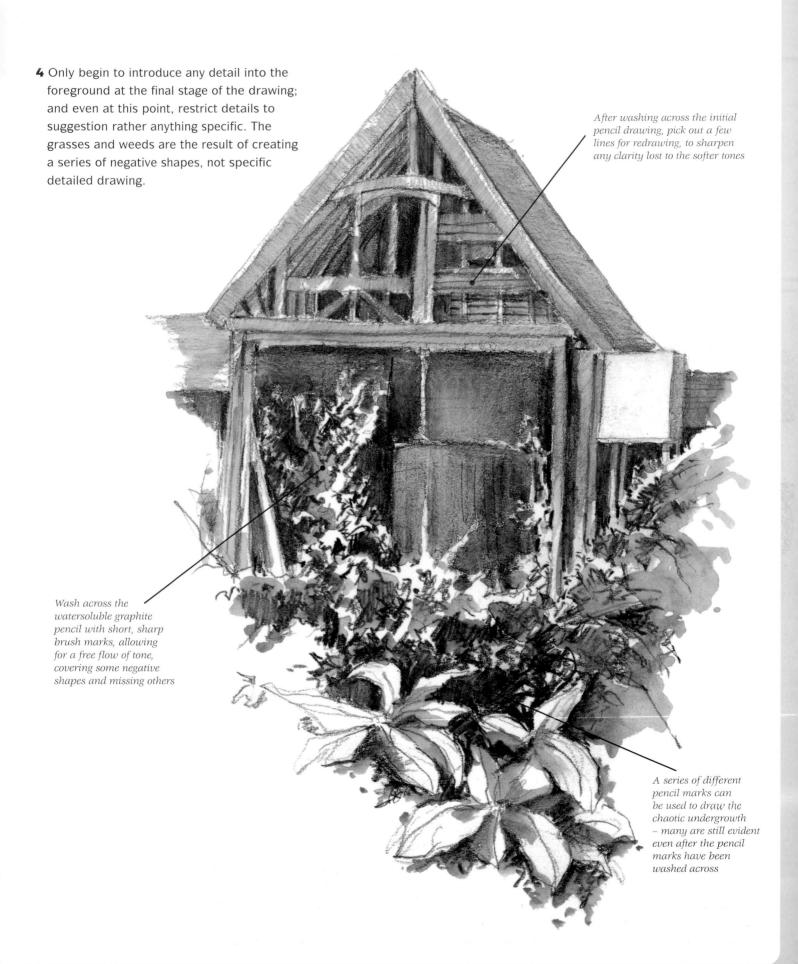

The term 'landscape' can sometimes be a little deceptive – often the most dominant part of a landscape is the sky, so you need to concentrate on this, rather than on the land.

You can use any medium for landscape drawings, but skies and clouds are best represented by the softer ones – pencils and watersoluble media. Start by experimenting and pushing the media to their limits: take one scene, for example, and record it in three different media to enable you to develop a strong feeling for the most suitable. Clouds have soft edges and are therefore best drawn with pencil rather than pen, but this does not mean that you cannot use ink for the sky! Try it and see what happens.

Using different media

A 6B pencil is useful for drawing any type of cloud. Use the edge of the lead to create the soft tones of the sky and cut into the clouds where necessary. Smudging should rarely be used, but just a hint of graphite on a finger can be easily touched onto the white of the cloud to give it a little tone.

Watersoluble graphite pencils give a fluid feel to a sky drawing. When you begin to wash across the drawing, it is important to maintain a directional sweep with your paintbrush to create a sense of movement in the picture.

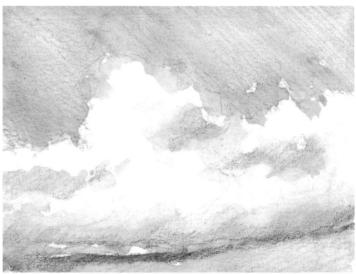

You will rarely use just one coloured pencil in a sky scene – the blue of the sky and the grey of the cloud require at least two, if not three, different pencils. Blending is the key to success here, steadily working one colour across another until you create a new one.

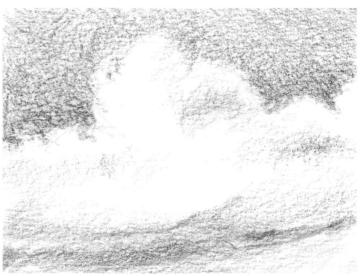

- 1 The first stage of this landscape drawing is to establish the horizon line and the approximate position and shape of the large cloud that dominates the picture frame. Use just a few pencil marks for this.
- **3** To create the foreground, gradually increase the depth of tone as you work towards the bottom of the picture frame, providing an illusion of several miles of space on a two-dimensional sheet of paper.

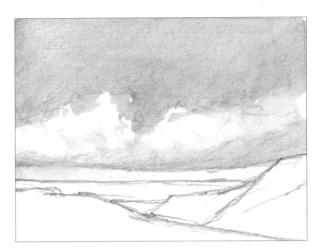

2 Next, draw in the sky with a watersoluble graphite pencil around the cloud, creating a large white, negative shape, then wash across this in a diagonal sweep. Quickly wash a little of the wet graphite left on the brush onto the cloud before it has time to dry, to develop the soft tones.

Diagonal drawing

and directional washing help to create

a sense of movement

A few pure white flecks of paper — at the top of the cloud shape add sparkle to the sky

Once a
watersoluble
graphite wash
is dry, you can
work on top of it
with the edge of
the pencil lead
to create soft, yet
strong tones

Creating depth

We are all very aware of seeing depth in a landscape: the further away things are, the smaller they look. When we come to draw this, however, we often find that the element that gives the sense of depth is the space in between the background and foreground - and as space is often only fresh air, this can be difficult to draw.

The answer is to mark clearly the boundaries in your drawing between the horizon and the immediate foreground, then to ensure that your foreground is sharp and well defined, and that the background is soft and suggested. The space in between should then emerge naturally as a series of graduated tones.

Depth in stones

To successfully create a sense of depth in a landscape drawing, it is essential to define the foreground clearly. This stone cairn was drawn using the sharp tip of a 2B pencil, noting the shapes of the spaces between the rocks as well as the outer shape.

Next, I introduced the main shaded areas by using diagonal lines drawn across the rock face where the darkest sections were. To add some colour, I drew across all of this using a yellow ochre coloured pencil, maintaining even pressure throughout the drawing.

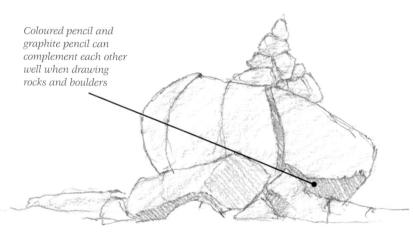

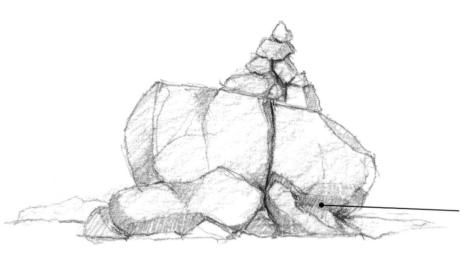

The inner shapes in the rocks needed sharpening in the final stage. To do this I used the same yellow ochre pencil but applied considerably more pressure to achieve a darker tone. I also used a sharpened 6B pencil to strengthen the lines along the cracks and fissures.

More yellow ochre on top of the shading enhances the look of

1 The first stage is to consider exactly where the furthest background line is, and then where the nearest foreground detail is. Once you have done this, sketch in the shapes or areas in between to act as markers for the next stage.

2 Next, consider the middle ground and create the shade that separates the foreground and background areas with a 4B pencil; this is an important division as it begins to create a sense of depth.

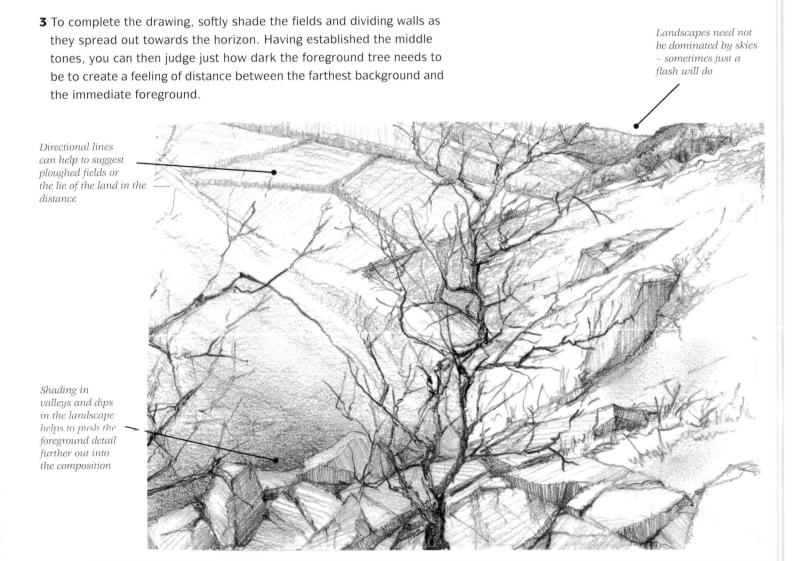

Panoramic seascape

The unlimited angle of vision that you have when standing beside a vast expanse of open sea makes the appeal of a panoramic view very tempting. The sea always presents many challenges to the artist, mainly because it is constantly moving, forcing us to draw heavily on our visual memories, catching and holding small images in our heads as if they were thumbnail sketches.

The weather also plays an important part in the type of drawing that you create: a windy day will provide the contrast between breaking white foam and deep, rising waves, while a calmer day will require you to use softer, more graduated shading.

Movement

The first stage of capturing the sense of movement in this breaking wave was to quickly sketch the angle of the break. capturing the shape of the white foam plume. The water that follows fast behind can be represented by a few quickly sketched lines.

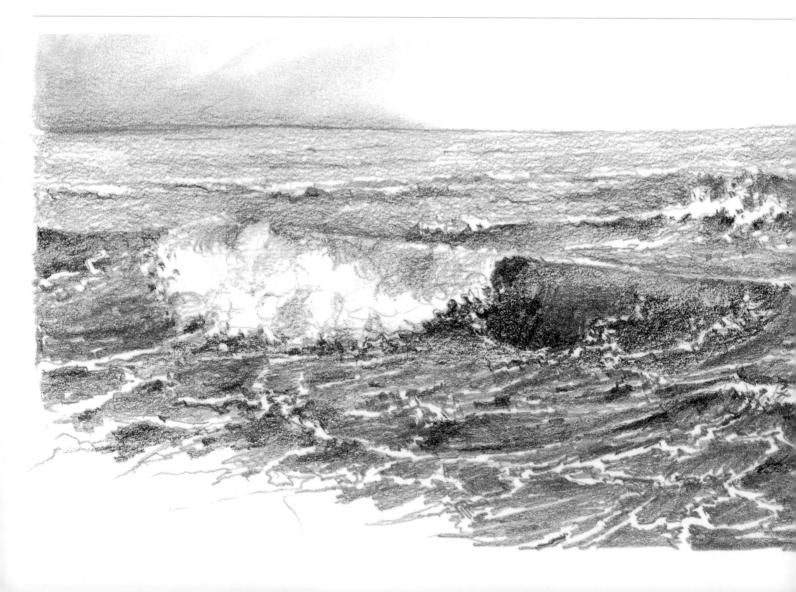

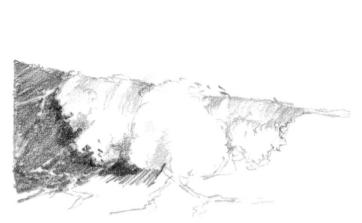

To ensure that the foam looks as fresh and clear as the real thing, start to shade around the shape using a 4B pencil, increasing the intensity of tone directly at the base of the crashing foam.

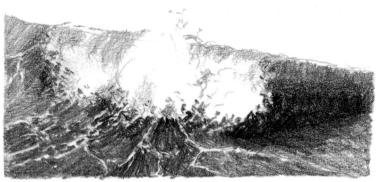

The trails of foam running along the length of the wave are also drawn as negative shapes, but on a much smaller scale. The shadow cast by the height of the wave is created using the tip of a 9B pencil to give some real depth of tone to the drawing.

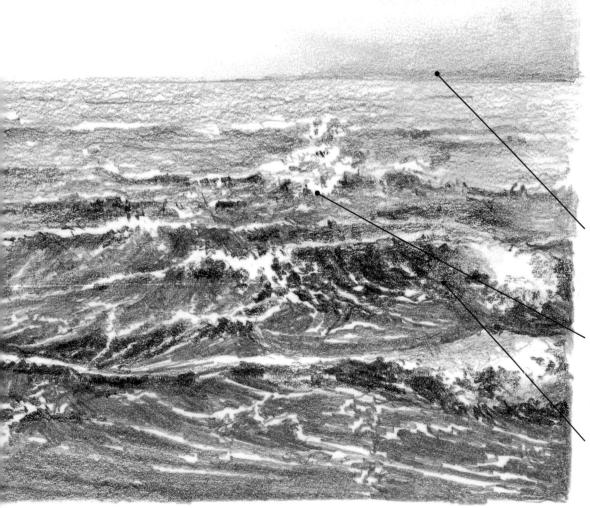

Panorama

This vast expanse of sea took longer to draw than most other pictures in this book, mainly because of the level of observation required to record the way in which the sea was moving on that particular day.

The soft hazy clouds building on the horizon are drawn with the edge of the lead of a 4B pencil and applied with a gentle touch

The crests of the waves are picked out at the initial sketching stage and left alone from then on. As the tone on the waves is added, so the white appears to stand out

Waves create shadows as they rise and fall. These darker sections are drawn with the tip of a 9B pencil, adding a real sense of depth to the final drawing

PROJECT: Country lane

When you go out on drawing and sketching expeditions in the countryside, you will be met with a huge choice of subjects. So the question to ask may well not be 'What should I draw?', but 'From what position should I draw it?'

I chose a slightly unusual viewpoint for this drawing, positioned on a corner with all the potential uprights leaning at unnatural angles; however, it was this odd collection of shapes that made the scene all the more interesting. By working in pen and ink I hoped to recreate the slightly stormy sky and the intensity of tones in the foreground – and the pen lines helped to hold it all together.

1 There are three key sections involved in drawing this country lane: first, the outline of the background buildings; second, the converging lines of the lane and the ploughed fields; and finally, the wild weeds and plants of the foreground that are sketched here, emphasizing just a few shapes.

3 The next stage is to recreate the huge variety of tones seen in the undergrowth. This can be done by working with a stronger, less diluted, Indian ink wash towards the lower section of the ditch where the light cannot penetrate.

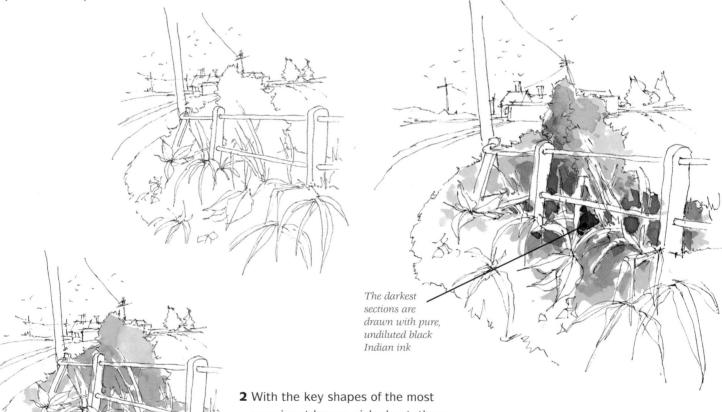

prominent leaves picked out, these need to be made to work by starting to develop the tones of the deeper undergrowth behind them. Start this process by applying a wash of highly diluted Indian ink, working around the drawn shapes, but not too carefully.

4 Having completed the foreground, draw in the lighter tones of the middle and background, using the initial pen sketch as guidelines. Choosing to leave the actual lane pure white is a visual trick that always leads the viewer's eye out towards the horizon.

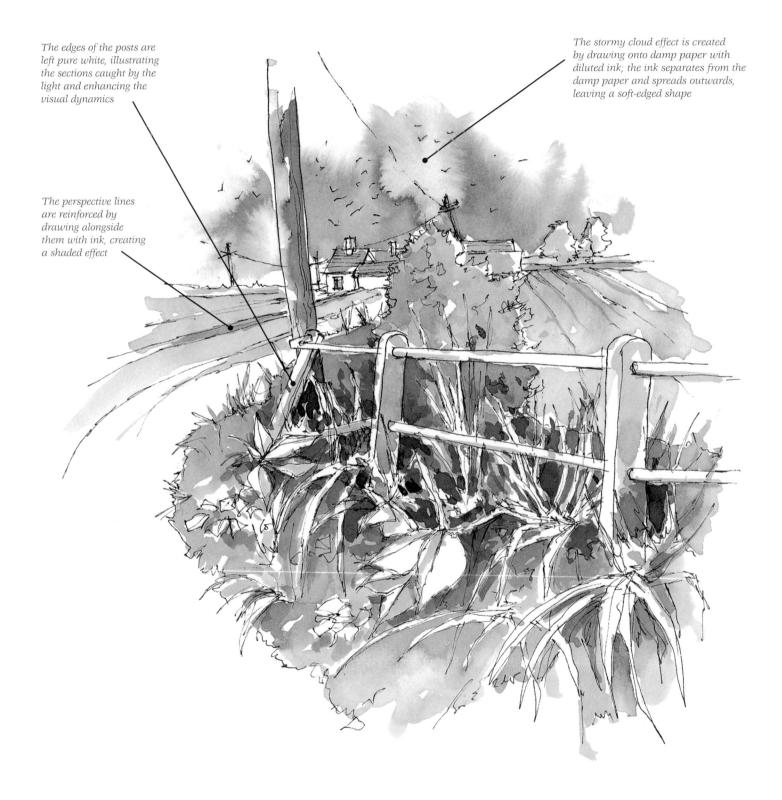

Final thoughts

It has been a long journey. We started off with oranges and now, with confidence, are drawing buildings in a hostile outdoor environment. So the next question to be asked has to be, what next? Where exactly do you go from here?

I have several suggestions. First, it is essential that you carry on drawing on a regular basis – ten minutes every day will really help you synthesize your skills, and is much better than one hour each week. Wherever you are – at home, on your lunch break at work, on holiday, waiting at an airport or railway station - try to use your time to fill that small sketchpad that now lives in your pocket wherever you go.

Second, seek out the company of like-minded people. Art clubs are wonderful organizations and are invariably extremely pleased to welcome new members. These clubs arrange all sorts of events, including demonstrations. sketching trips and even club exhibitions. You will find that being with people who share your interest will spur you on to try new things.

This leads to my third suggestion: now start to experiment. You have used the basic equipment over the last few weekends, and it is now time to explore other drawing media – charcoal and chalk, for example, will force you to work with less accuracy and on a larger scale. You might even like to try working on different types of paper - don't restrict yourself to cartridge paper. In fact, there are absolutely no limits to where your drawing may go, and you may find yourself drawing subjects you had not considered when you began.

But whatever else you do, I hope that the past few weekends we have spent drawing together have enabled you to develop skills that allow you to say to yourself what I said at the very beginning - you can draw!

Index

angles 46, 47, 91, 116-17

barn, wooden 110–11 bleeding of colours 16 blending 10, 12, 13, 90, 93 blocking in 11, 12, 13, 58, 66, 101 boats 96–97 box shapes 48, 104–7 brush strokes, visible 13 brushes, watercolour 16 brushmarks 68 buildings 104–11

cafés and bars 98-99 charcoal 6 clothing 64-65 clouds 112-13, 117, 119 colour 70-71 complementary 70 for drawing flowers 86-87 reflected 48 wheel 70 cones 18-19, 24-25, 28, 57 tones and highlights in 22-23 converging lines 32, 33, 34, 46, 48, 78, 105 cottages and houses 108-9 'crating' 33, 49 crayons 6 crosshatching 8, 14, 20, 21, 68, 75, 89 cube angles 32 cubes 18-19, 28, 48-49, 76 shading 32, 48-49 curtains 76, 81, 101 cylindrical shapes 38, 56, 57, 63.88

depth 46, 114–15 detail, adding 52–53 diagonal drawing 113, 114 distortion 44–45 doors 78–79 dotting 15, 69

erasers, kneaded 6, 33, 4 9, 67, 80

farmyards 94–95 finishing a drawing 4 fixative spray 6 flowerpots 19, 84–85 flowers 76, 84–87, 92–93 foliage 81, 99, 118 foods 72–73 foregrounds 62–63, 114–15 formats, square, portrait and landscape 30–31

garden sheds 104–5 gardening tools 88–89 glass 42–43 distortion through 44–45 glass ball 96 greys, making 12

harbours 96–97 highlights 11, 15, 18, 22, 23, 25, 27, 33, 36, 38, 57, 66, 96, 107 on glass 42, 43 horizon 32 huts and cabins 106–7

Indian ink
applied with brush 15, 108
washing with 14–15, 29
indoor drawing 34
ink, creating tones with 22

lane, country 118-19 Leonardo da Vinci 4 lettering 44-45, 47, 51, 52, 61, 100, 101 lifebelt 96 light reflection of 24 studying 18 light and shade 24-25, 43, 98-99 lighting indoor 34 outdoor 82 line drawing 8, 9, 20-21 for shading 20, 59 directional 13, 14, 115 space between 14, 20

machinery 94–95 mark-making 68–69 markets 102–3 materials, dry and wet 6 measuring 28 movement 116–17

varying width 59

organic forms 66–67 overdrawing 10, 11

padlock 106 paints, watercolour 6, 16-17, 37, 39 paper cartridge 4, 16 watercolour 16 white, left untouched 42, 43, 60, 65, 97, 98, 113, 119 pastels 6 pen and ink, techniques 14, 118-19 pen and wash 84-85 pencil marks, as effect 92, 111 pencil sharpeners 6 pencils 6, 8-9, 24, 50, 59 coloured 10-11, 20, 22, 41, 43, 51, 73, 74-75, 76, 84, 85.87 creating tones with 22 grades 8 line drawing with 20-21 techniques 8, 10 watersoluble coloured 6. 12-13, 24, 47, 60, 63, 66, watersoluble graphite 6, 12, 22, 27, 44, 52, 57, 64-65, 68-69, 72, 76, 81, 88, 90, 96, 110-11, 112-13 pens 6 fibre-tip 14-15, 50, 84 fineline or permanent ink 14 - 15, 29line drawing with 20-21 perspective 34, 78, 82, 105, 119 tabletop 32-33, 53, 62, 76 Picasso, Pablo 4 positive and negative shapes 26-27, 43, 51, 53, 66, 67,

rectangular objects 46–55 adding details 52–53 shading on 48–49 shadows on 50–51 reflections 29, 42–43, 59 round objects 36–41 shadows on 40–41

97, 108, 111

71, 72, 73, 79, 91, 93, 94,

pressure 8, 21, 22, 25, 41, 51,

74, 96, 103, 114

seascape, panoramic 116–17

shading 8, 18, 20, 21, 26, 27, 33, 36, 38, 54, 58-59, 71, 101 coloured 58, 75 shadows 9, 11, 13, 23, 33, 36, 40-41, 53, 55, 58-59, 67, 89, 102, 109 curving 84 in foreground 52-53, 77 hard-edged 91, 99, 107 of waves 117 shapes, basic 18-19, 24 shop fronts 100-101 sketchpads, ringbound cartridge paper 4, 82 skies 112-13 spaces between shapes 33 spheres 18-19, 24-25, 66, 67 spring scene 92-93 still lifes 56-59, 74-75 shading on 58-59 stippling 15, 69

texture 68–69, 95
three-dimensional effect 11, 18, 19, 49, 50, 79, 101
tones 9, 10, 11, 13, 14–15, 21, 22, 23, 48, 53, 95, 102
tractor 95
transparency 91
transparent objects 28, 37, 42–43, 84
trees 90–91

undergrowth 110-11, 118

vegetables 66-67

stone 108, 114

washes 16–17, 37, 39, 47, 50, 53, 60, 84–85, 86, 98, 99, 105, 109, 118 diagonal 113 watercolour, techniques with 16–17 watering can 88 watermarks 85, 98 weather 116 wet-in-wet 16 windows 76–77, 101, 109 open French 80–81 wood grain 21, 77 wooden structure, creating 21 woodwork 81, 104–7, 110–11

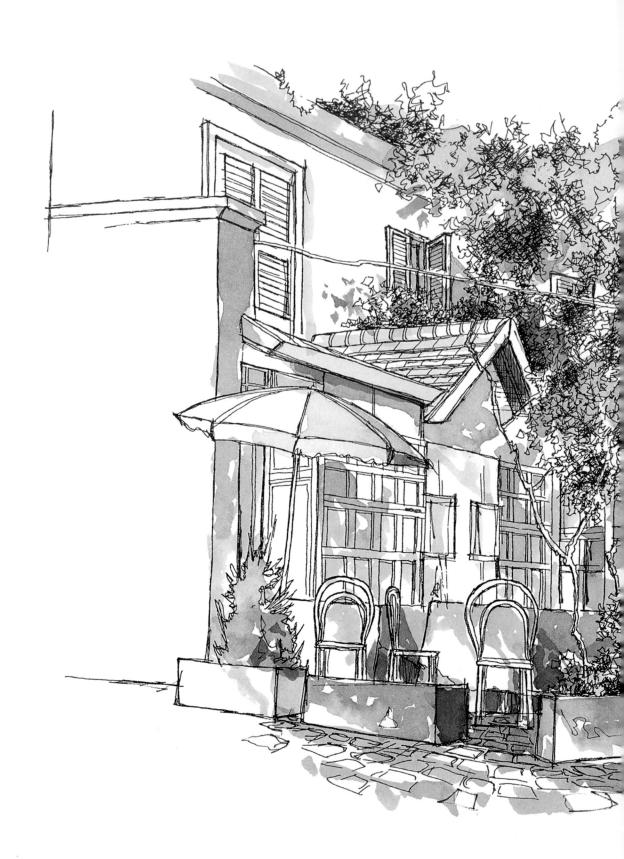

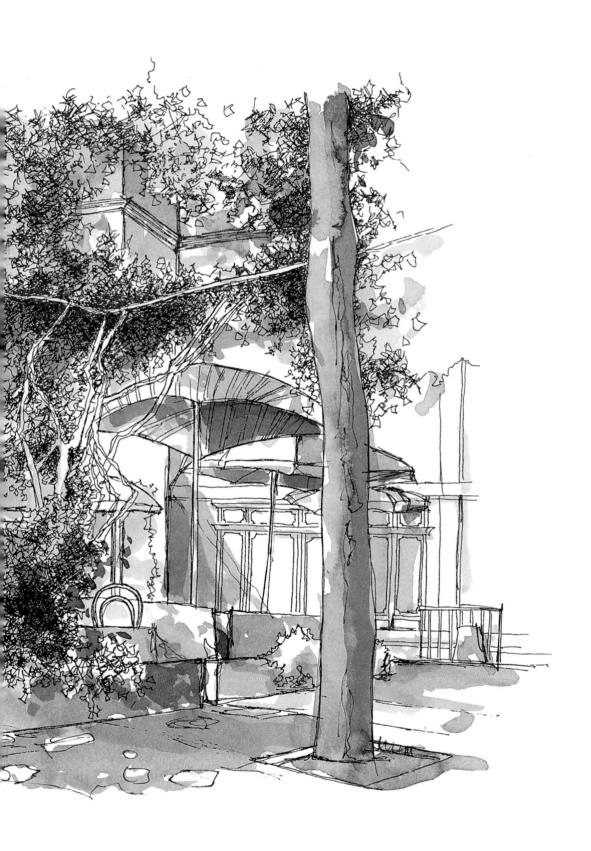